LIVING A
BEAUTIFUL
LIFE

LIVING A BEAUTIFUL LIFE

500 Ways to Add Elegance, Order, Beauty and Joy to Every Day of Your Life

Alexandra Stoddard

Illustrations by Pat Stewart

AVON BOOKS
A division of
The Hearst Corporation
105 Madison Avenue
New York, New York 10016

Copyright © 1986 by Alexandra Stoddard
Front cover photograph by Ed Carey
Published by arrangement with Random House, Inc.
Library of Congress Catalog Card Number: 86-3846
ISBN: 0-380-70511-7

First Avon Books Trade Printing: April 1988

AVON TRADEMARK REG. U.S. PAT. OFF. AND IN OTHER COUNTRIES, MARCA REGISTRADA,
HECHO EN U.S.A.

Printed in the U.S.A.

RRD 10 9 8 7 6 5

To my mother
who really believed beauty is truth,
truth beauty,
and lived her belief every day

A NOTE TO THE READER

Making the things you do every day as beautiful and pleasurable as possible is a way to live a happy life. Yet many of us don't seem to do this.

In my work in interior design, I've noticed that many people have a tendency to save up 95 percent of their money and effort to spend on 5 percent of their lives—festive occasions such as birthdays, anniversaries and holidays, and the special, more public places in the home, such as the living or dining room. Instead, the way to live a beautiful life is to make the daily 95 percent of your life wonderful.

The aim of this book is to help you do just that.

We'll get to know you better, and talk about some of the daily, weekly, seasonal or yearly rituals you might want to create, to help you live the way you want to live, and to do it beautifully. My suggestions are by no means revolutionary, nor are they comprehensive. My aim is to inspire you, by useful examples, to go ahead and create beauty and ease in the areas of life that mean the most to you, day after day. Rather than trying to be definitive, I'm trying to provoke and inspire you to set up your daily life for effectiveness and grace. We'll talk about three of the activities most of us do every day—eating, sleeping and bathing. We'll broaden out into other rituals, especially those of sharing yourself with people. And at the end of each chapter, you'll find "Grace Notes"—more details of things you can do to help you live a beautiful life.

CONTENTS

Ritual is the technique for giving life.

THOMAS J. PETERS AND ROBERT H. WATERMAN, JR.
In Search of Excellence

A little thing comforts us because a little thing afflicts us.

PASCAL

LIVING A BEAUTIFUL LIFE

CHAPTER 1

RITUALS

To be happy at home *is the ultimate result of all ambition,
the end to which every enterprise and labour tends . . .*

SAMUEL JOHNSON
The Rambler, *November 10, 1750*

Creating daily rituals—making daily tasks into times of enrichment through planning and special personal details—is a way to live a richer, more satisfying life. It may seem an obvious point—yet it is so easy to do! But in my work as an interior designer, I have found that many people need advice about re-designing the *small* details of everyday living: they need this much more than they need advice about how to design a brand-new living room.

Samuel Johnson is a hero of mine. His life was not an easy journey, yet he lived day by day with a sense of urgency, reverence and passion. "The process," he insisted, "*is* the reality." As I've worked in the decorative arts over these past twenty-five years, I've become convinced that only by paying careful attention to the simple details of daily tasks and to our immediate surroundings can we live vitally and beautifully all the days of our lives. It takes a commitment to enjoy each day fully. And it takes respect for the significance of grace.

"Rituals" is my term for patterns you create in your everyday living that uplift the way you do ordinary things, so that a simple task rises to the level of something special, ceremonial, ritualistic.

3

Rituals can elevate the way you feel about yourself, your life, and make you more peaceful and more free, more useful to others.

The difference between feeling bored and feeling alive, I believe, lies in a stimulating daily life that is elevated into a fuller experience through pleasing details.

When these small moments are handled lovingly and with thought and care, they become life-enhancing and make you capable of doing more with the rest of your time.

I've observed in my communications with people all over the world the tendency so many of us have to concentrate our energies on things that are for special occasions rather than on things we do, or use, every day. In design terms, this translates into working to get the living room just right, instead of concentrating on the rooms we spend the most time in, day after day—the kitchen, bedroom, bathroom. This 5-percent rule translates into a tendency to save up a sense of the special for a few outstanding events each year—for a particular party, anniversary or birthday celebration, a vacation. Such events comprise at the most 5 percent of our living time, and the remaining 95 percent is often merely walked through, in wistful anticipation of some later joy. But what we all really want to do, I think, is *live* in the present, really enjoy every day, not put our lives on hold for that special 5 percent. We want to enjoy all the days of our lives, and especially the time spent in the sanctuary of home. Life is not a dress rehearsal.

Instead of rushing through our lives to get somewhere—instead of saving up real living for later—I think it's important to remember that each single day is all we have. Single days experienced fully add up to a lifetime lived deeply and well. *Today* is your life—not yesterday and not tomorrow. If we have tomorrow, it will be a gift, but what we do today, right now, will have an accumulated effect on all our tomorrows. If we make short shrift of our day-to-day lives, even if we live to experience "later," I don't believe we will know fully how to appreciate what we have. Living well is a habit, and rituals improve and reinforce good life habits.

That nimble writer of aphorisms Logan Pearsall Smith, in his book *All Trivia,* said: "There are two things to aim at in life: first, to get what you want; and, after that, to enjoy it. Only the wisest of mankind achieve the second."

Special events should be exclamation marks in our lives, but ordinary days need to be celebrations too, as meaningful and beautiful as the big events.

Small personal touches added to the things we do repeatedly create rituals that give us confidence and energy. You have power over your daily life; you can set up useful systems that will help you sustain these rituals in many satisfying ways.

As I look back on my childhood, I see now that I had an early tutor in this attitude toward daily rituals, and also in what became my field—interior design: my mother. She created a beautiful home environment, which helped me learn how to see and how to live. Writers have to find their own voices. I had to learn how to see.

Mother's innate aesthetic sense affected everything she did. When I think back to the meals we ate together as a family, I remember the fresh flowers on the table, the food attractively arranged on the plate and planned partly with color in mind. To Mother, truth was beauty lived every day. Not only did Mother teach me to appreciate beauty by her example, she also taught me an invaluable lesson— the importance of creating beauty each day, and how to do it. By her example she conveyed that beauty was essential for happiness and an alloy of love.

People's basic living needs are remarkably simple, and they haven't changed a great deal since the Stone Age. We eat, sleep and bathe. We do these things every day.

Setting up beautiful details in these three areas can make an enormous difference to the quality of your life. There is a chapter in this book on each of these activities and ways in which to elevate them into richly restorative events.

There are also other habitual tasks which, when transformed by

personal details, can become special. We'll discuss these tasks, too.

To establish the base, all the right essentials must be in place. When they are, the way you handle the details will not only color your life, but will set standards of excellence for others to follow.

Even small embellishments can elevate chores into fun; pleasing details change the things we do into activities that celebrate being alive, and that shore us up for the rigors of life. Rituals bring warmth and comfort; they give you things to count on enjoying every day.

Rituals are patterns, and as such they can help us have a wider perspective, so that we enjoy more fully the only real journey of our lives—our day-to-day existence. Being happy and peaceful, especially at home but also in any place where you spend a lot of time, is the goal: stimulating the senses is one way to start.

I've learned to tease myself into doing necessary and useful tasks by stimulating my senses as I go along. For example, as I write, my broad-tip fountain pen squeaks across glossy white paper, a page from a red notebook bought at Marimekko, imported from Finland. The combination of the smooth feel of the paper, the flow of clear blue ink on sparkling white pages and the smart look of the notebook with a ribbon to mark the page—even the musty schoolhouse smell makes me smile as I make notes, and so I enjoy the task of writing.

Stimulating the senses through the details of daily acts makes work fun. I like to work, but I've learned to make a project mine by setting it up so it will be pleasurable for me. The more senses I can involve, the better. I know that by heightening sense awareness in the acts I perform I can enrich the activity and make the time I spend doing it more enjoyable. And so I deliberately try to awaken the five senses in whatever it is I am doing.

I have a friend who has made bill paying into a ritual. She puts Brahms on her stereo, she places an arrangement of flowers on her desk, she dresses in a fresh blouse and skirt so she is actually ready

to mail her bills as soon as she's finished. She has elevated a necessary task—bill paying—into a ritual through the details surrounding how she does it. She finds it satisfying in part because she's involving the senses in the process, and also because of the order and manner in which she goes about it. There is a feeling of accomplishment in both the process and the result. The sight and scent of the flowers, and the music in the background create a mood that calms the spirit.

Taking time to make bathing a ritual—using Chanel No. 5 or another delicious bathing gel, a terrycloth face mitt, a special almond soap, planning on allowing yourself time to soak, read, sip a glass of orange juice, can give your whole evening a fresh beginning.

A pretty painting, if it's on your bedroom wall, can be appreciated by you each day; friends may enjoy it on occasions, but it is there mostly for you—and it should be in a place where you can see it all the time. The same principle should apply to your dinner plates, glasses, a charming set of colorful napkins, placemats to cheer up breakfast. These special things become details of a breakfast ritual; kept on hand for constant use, they enrich each day.

Making other kinds of tasks into rituals helps you stay in touch

with yourself and your friends. When you think of a friend and actually sit down at a place you've designed as your writing table, with paper, pens and stamps all set up to dash off a note or card, this ritual can be effortless and pleasurable when you're all ready for it. It takes just seconds and gives pleasure to you and to the recipient. Note writing is all too rare today, and therefore it's especially appreciated. Who do you know who wouldn't like to receive a friendly handwritten note? I always thumb through second, third and fourth-class mail looking for one. My husband keeps in touch with people from all over the world by sending clippings from newspapers and magazines. "Brown's Clip Service" is a sustaining daily ritual for Peter. If you read something in the newspaper that triggers you to think of a friend, clip it and put it on your desk to send on with a note.

A detail of my note-writing ritual that I enjoy is collecting bottles of ink in different colors. In my desk drawer I have bottles of blue, red, black and purple ink. The variety of colors stimulates me. Using different colored inks from time to time wakes up my senses and gives me a boost of energy; it's part of my enjoyment in dashing off a note to a friend.

Another touch I appreciate is sealing a letter with wax. I keep several sticks of wax on my desk—red, blue, green and purple.

Joyce Carol Oates, in her book *Solstice,* writes about the clock, pointing out that it runs in one direction only: None of us can afford to take our daily lives for granted. Time can never be made up. When you deprive yourself of an enriched daily life, you rob yourself of happiness that can be easily achieved—the art of really living. Rituals begin at home.

When you invest richness in the things you do every day, it helps to keep daily life from seeming bogged down or frustrating.

And making tasks into rituals actually *saves* time. It takes some effort in the beginning to think about and institute rituals, and to set up your home for them. But you also have the fun of creating them, and then they tend to sustain themselves and you. Rituals

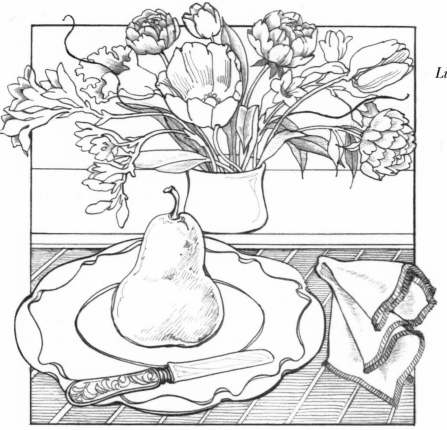

help you make the most of time and help you feel you *have* more of it because you are enjoying yourself more deeply as you flow through the day, adding touches that stimulate enthusiasm and give energy. Daily rituals help eliminate that enervating feeling of being constantly fragmented. A ritual is a mini-performance, whether privately performed or shared with a friend, and it has a life of its own.

Most of us spend the largest portion of our lives at home; we need to pay special attention to the details of the lives we live there.

My work allows me to help set a stage and a background for the way people want to live their lives, and I find they need as much help on the small details as they do on the big, expensive invest-ments. Yet once a personal environment is created in the small

Alexandra Stoddard

10

details—how one's closet is arranged, for example—one finds oneself living in rich soil that encourages vitality and individual expression—a life lived fully and well. How do you want to live? What activities give you the most pleasure, day by day? You are the actor, the lead character in your life. What rituals will support your roles? No one can dictate the styles and tastes of your rituals—these depend, to a greater extent than most of us realize, on stimulating all your senses and on living out your dreams, your inner visions, your sense of self—and of how you want to spend your time, your fantasies and your passions.

Several years ago I was seated overlooking a harbor with a friend. She turned to me and said, "Alexandra, my ship has never come in in my whole life. My ship of joy, of expectation, of hope, of romance —it has never come in." The same might turn out to be true for many of us—the great dream never quite realized, the great ambitions never quite achieved. But if we live each day deeply, at the end there may be fewer regrets; at least, each day, we will have sent our ship out to sail. Daily rituals are personal statements; they fuel our zest for living.

All of us work. Whether paid or volunteer, at home or in an office, we should create our own little territory that we can personalize and make our own. Personalizing our workspace puts our autobiographical stamp on the varied and diverse things we do for others in our work.

You can personalize your workspace through color—colored folders, pencils and pens, desk accessories. Even the paper clips you use, whether they be gold-colored metal or in a variety of colors, can add just a little personal touch to your work.

I always have fresh flowers at my workspace, even if it's three daisies in a little vase. And I have a handful of my favorite books near me for inspiration and reference. A dictionary is always on my desk, covered with a print of a still-life by Henri Fantin-Latour, my favorite flower artist.

I believe beauty can be achieved in the smallest, simplest ways,

and this beauty enriches your work experience. The attitude of
caring about beauty in the least of things can elevate your work
experience into a creative art form.

Rainer Maria Rilke wrote in his *Letters to a Young Poet:*

So rescue yourself from these general themes and write about what your
everyday life offers you; describe your sorrows and desires, the thoughts
that pass through your mind and your belief in some kind of beauty—
describe all these with heartfelt, silent, humble sincerity and, when you
express yourself, use the Things around you, the images from your
dreams, and the objects that you remember. If your everyday life seems
poor, don't blame *it*; blame yourself; admit to yourself that you are not
enough of a poet to call forth its riches; because for the creator there is no
poverty and no poor, indifferent place.

Personal rituals make you a poet—and they can help you feel
good about yourself and others. They reinforce the significance of
the simple acts we perform repeatedly. While you are fulfilling basic
needs, you can make the ordinary quite extraordinary. When you
make your everyday rituals—simple things such as bathing, sleep-
ing and eating—meaningful and attractive, they nourish other areas
of your life.

Creating rituals requires instinct for what you like, and some
time in setting up and sustaining the details. Poets, writers and
artists all have highly personal rituals to stimulate their work; fish-
ermen have rituals; so do ballerinas. Why not all of us, at home?
People have always lived by ceremonies; the daily rituals you create
allow you to make the most of what you have, and to stretch time
by savoring moments.

Emily Dickinson lived most of her life in one house in Amherst;
yet she wrote, "I dwell in possibility." In your own style, in a
noncommercial, nonpolitical, nonspectacular way, you can forge
individual rituals which can give you the greatest gift of all, the art
of living richly and fully. I believe that if you take care of the small

things, the big things take care of themselves. You can gain more control over your life by paying close attention to little things.

Rituals and details are not ends but steppingstones, tools to aid us in the enjoyment of the actual process of living as fully and creatively as we possibly can. Values and rituals are intertwined; through rituals we can express our values, giving our lives dignity, vitality and joy.

Emerson said, "Every spirit builds itself a house, and beyond its house a world, and beyond its world a heaven. Know then that world exists for you."

> "*. . . There is no there* there *. . .*"
> GERTRUDE STEIN

One of the real goals of having rituals is to make sure there is ample time given to making the small things in our lives count. In this way, we enrich the *whole* of our lives, and the continuity provides daily and weekly enrichment.

What follows are "Grace Notes"—other details to add to the rituals of your life.

GRACE NOTES

• Work smarter, not harder. When you feel overwhelmed, take a break from whatever is causing you pressure and attend to some necessary tasks that will please you and bring instant gratification. Organize your desk top or a drawer or two. Then go back with new energy to the bigger tasks.

• When you're feeling out of sorts and blue, pick up a favorite art book and rejuvenate yourself through the beauty of the pictures.

• Spray cologne in a box of stationery and put the top back on. The wonderful scent will be there for you as soon as you open the lid to write a note. The recipient of your letter will enjoy it as well.

- Go to a specialty store, and buy some small, distinctive item. For instance, Tender Buttons in New York is a wonderful little store that has turned the button into an art form. I go there and buy a set of blazer or other buttons to spruce up an old coat. This makes me feel wonderfully refreshed.
- Line the inside of your closet door with art postcards. Use double-sided Scotch tape so you can peek at the back if you need to check an artist's name or the name of the painting. Get dressed with art.
- Mark new seasons with childhood reminiscences: In spring, fly a kite, In summer, make a sand castle, In fall, rake leaves and go hiking, In winter, go for a walk in newly fallen snow.
- Hang a favorite quilt on your living-room wall behind your sofa, or in your bedroom over a loveseat. Use Velcro on a wooden strip and sew Velcro on the top of the quilt to protect the edges.
- Be three minutes early for your next appointment and wait calmly. While you'll show respect for someone else's time and life, you will also have time to compose your thoughts.
- Lift your mood with a new fragrance.
- Have a friend bring you some piñon incense from Santa Fe to burn in your fireplace. Once you do, you'll be hooked.
- Burn up calories as you bustle around tidying up. Put on running shoes and be aware of bending from the waist as you pick things off the floor. Fast fixing up can be almost aerobic-like when you do it to jazzy music.
- Buy a brightly colored exercise roll and do Yoga or sit-ups when you feel tense.
- Take a few minutes to be alone several times each day. Concentrate on your breathing. Meditate. You will emerge refreshed.
- Daydreaming can help the brain promote essential cross-circuiting of your creativity. Give your brain a nap; it will work smarter.
- Walk to appointments. Program enough time to enjoy the sights along the way. Look up at the architectural detail, notice the win-

dow displays; browse. Exercise, especially before being confined in a conference room, keeps your energy level high. You'll be amazed how clearheaded you'll be for your meeting.

• Dressing is like room planning. Usually there are two to three predominant colors in a wardrobe as major themes. Really do what the fashion magazines say—plan your wardrobe around two or three basic colors for each season, colors that go together. Dressing is easier and more flexible and fun. Daily dressing and packing for a trip both become simpler, because you aren't tempted to add extra things that don't mix or match. Simplify, and be inventive with your color schemes.

• Keep a notebook in which to record your child's words and sayings.

• Buy a set of thin water-soluble and long-lasting colored pencils. Fill a mug or glass with your favorites, and display them on your writing desk.

• Make your own quotation book. Every time you read or think of something you want to remember, enter it in your book. Reviewing your quotes gets you thinking.

• Make a personal source guide. When you discover a store that has products you like, make a note; order by phone or mail, if possible.

• Being organized saves time, enabling you to accomplish more and feel more satisfied with yourself. Keep a careful datebook, and weed it out each month.

• Have a special basket for the mail. It looks pretty, and it's fun to bring into the living room or library, to open at leisure.

• For a wonderful surprise, insert a French "Fragrance on the Line" plastic disc of pure extract of perfume inside the mouthpiece of your telephone.

YOUR OWN GRACE NOTES

CHAPTER 2

CREATING SOMETHING SPECIAL
OUT OF THE ORDINARY

*Y*ou transform daily tasks into meaningful rituals by paying careful attention to the small details that go into those tasks. Your senses can help you, can be your lightning rod, a guide to how you want to enliven your daily life.

This chapter is about some of the things most of us do daily, weekly, seasonally or yearly—or *wish* we did; it is also about how to add the right details to these tasks so that you enjoy them, and your daily life, more fully. In this way, they become elevated into rituals, and move up to a more meaningful plane.

A great deal of our lives is made up of tasks. The little details and habits of daily life, carried out with a sense of pleasure and beauty, can be just as important to us as the tea ceremony is to the Japanese. The way you handle the details of a meal or a bath, of paying your bills or doing your exercises, can turn something ordinary and mundane into something quite extraordinary: supper becomes more of a celebration if you add a centerpiece of fresh vegetables to the table—artichokes, tomatoes and zucchini; you have this food on hand to be eaten, why not enjoy looking at it now? You can make a bath memorable by slicing lemons, limes or oranges and sprinkling them on clear, room-temperature water.

Much of enjoying life is in the details—the larger issues have a way of working themselves out. Handling daily tasks well and thoroughly affects how we feel, our happiness and the overall quality of our lives.

To paraphrase the psychologist Ernest Becker, society is a vehicle for earthly heroism. Men and women transcend mortality by finding meaning in life. It is the burning desire for each of us to count for something. "Ritual is the technique for giving life," says Becker, in the informative book *In Search of Excellence* by Thomas J. Peters and Robert H. Waterman, Jr. "Man transcends death by finding meaning for his life . . . what man really fears is not so much extinction, but extinction with insignificance."

The big picture sometimes looks quite grim. The outside world can seem troublesome, dangerous, uncertain. Frustrated by the difficulty of making a difference, we find it hard to grasp how we can effect change and make the world a better place in which to live. One's home is a personal space in one's refuge.

By creating beauty and order where you live and work you will be controlling the private hours of your life. Home, especially, is one area of existence where you can have control. By concentrating on easy, positive steps—the kind of toothpaste and shampoo and body cream you use, the contour and color of your sheets, the firmness of your mattress, a sunny place set up for lunch, the kind of paint you use, the temperature of your room and tub water—the smells and colors that surround you—these are the things that you can make right for yourself.

Our five senses need nourishment, and then they can nourish us. Just as we must develop discipline to set up our rituals, just as we must create intellectual discipline to continue to grow and learn, our senses need to be honed, encouraged and put to use. The poet John Milton invented the word "sensuous" in order to have a synonym for sensual that didn't have a sexual association. Eating an artichoke is a sensuous experience—the leaves are a perfect shape to hold and your teeth sink into the tender tips. Artichokes, like

fried chicken, are fun to eat at home because you can make of them an eating ritual. You can plan different dips—lemony sour cream, pure sweet butter, cold mayonnaise. Hands, teeth, eyes, taste buds go into the joy of eating an artichoke. What other examples of eating can you think of where your senses are fully awake? Lobsters, oysters, corn on the cob!

Why can't your sewing basket be a treasure trove of colorful buttons and thread that gratifies the senses—a basket lined in a provincial French cotton print or a charming Laura Ashley calico? Wouldn't it be a nice idea to sit in a sunny place and sew on a loose button if you had a wonderfully sensuous sewing basket? Throw in a lavender sachet and daydream about Provence—scent conveys an exquisite spirit of place.

I add a hidden dimension of color wherever I can find the slightest excuse—the colors of garden-fresh fruit, vegetables and flowers; variety is stimulating. I put raspberry-colored cotton mats on the floor of my closet and underneath them, as a soft padding, I have mint-green ones. When I open the closet door and flick on the light, I'm surprised by the joy of unexpected color. When the raspberry mats show signs of dirt I throw them into the washing machine, and am left with a green blanket of color underfoot.

The more you cultivate your senses the more you will appreciate subtle nuances—prisms of light from a crystal candlestick glittering on a ceiling, shadows cast by shutters against your shiny white walls, a rainbow of colors in your bath—the kind that gives you a foot of fluffy white bubbles, making you feel you're in the clouds. When you use the charming pottery plate you bought in Vietri, you remember and experience again the pleasure of your trip to Italy all those summers ago.

Luxurious, beauty-filled rituals give one a marvelous sense of well-being. Add color and flavor to everything you can, to increase your delight and quicken your spirit. Spray cologne on your note paper. Buy strawberry-scented erasers. I get excited about good smells. I'm strongly tactile—I like things to feel nice. Be conscious

of the texture of a cream, the feel of a rug on bare feet, the feel of a sweater against your neck. Choose things that pass the tactile test.

When you feel that the little things in your life are satisfying and speak specially to you, it's amazing how outside pressures and disappointments loosen their hold. Intimate, necessary details add up to one's private life. Select them with care because they *are* your life.

More and more I find we're turning inward to our houses and apartments as true havens on earth. The only place where we can "change the world" by what we touch and do is where we live. This decade has brought great changes for the better in attitude and spirit about where and how we live our private lives. I sense that there is a reassuring and renewed love of home.

As we approach the twenty-first century, we don't know what the future will bring; perhaps because of this, we're constantly looking back at traditional values. Americans seem to have a fresh respect for our heritage: one example is a renewed passion for and interest in antique quilts. Quilts are uniquely American, and they are becoming priceless examples of folk art. There is a reverence for the simple, quiet pleasures of living well and beautifully at home. Home is where we return for fulfillment and wholeness.

Think of the satisfaction women in an earlier age had working at sewing bees, recording the principal benchmarks of life—love, weddings, births and deaths. They stitched and patched together intricate bits of colorful cotton. And it is in our homes that we can become more truly ourselves by paying greater attention to the specific ingredients and finishing touches we select to change our homes into something that is uniquely our own, and our daily routines into graceful rituals.

"Living is so dear"

One day in March 1845, Thoreau borrowed an axe and went down to the woods by Walden Pond owned by his friend Emerson;

there, Thoreau built his house. For his solitary creation he spent $28.50! His house was his and his alone.

"I desire that there may be as many persons in the world as possible; but I would have each one be very careful to find out and pursue *his own way* and not his father's or his mother's or his neighbor's instead . . . I did not wish to live what was not life . . . living is so dear." Thoreau chose to be rich by making his wants few.

Thoreau spoke of scaling down. Many wise people besides Thoreau preach simplicity. Eleanor Brown, the doyenne of interior design in America, now in her mid-nineties, believes "We only need one set of roots. Living requires time." By not overextending ourselves we avoid fragmentation, clutter and nonsense. Life is too short for you to be caretaker of the wrong details.

When something small is right you can then forget about it and think about more lofty ideas. Einstein claimed he got all his best ideas while shaving; a daily ritual like shaving should be as pleasant as possible. Towels that absorb well, face creams that soothe, are like napkins soft to the touch, matches that light, garbage bags that hold, can openers that open—effective small things that are reassuring, if minor, discoveries. I'm willing to pay attention to the little things; when they're right they shore us up, when they're wrong, they are a burden. Life is fundamentally a matter of paying attention —it is up to us to improve the environment where we live by giving greater attention to the details that create personal rituals.

A friend was browsing in the Museum of Modern Art store in New York and saw a well-designed orange-juice squeezer in a glass display case. Suddenly she realized how wonderful it would be to have this handsome object sitting out on the butcher-block countertop in her kitchen; she envisioned it with a blue-and-white Spatterware bowl next to it filled with juice oranges. She bought the juice squeezer and she now uses it around the clock; when guests arrive at her house in the evenings she offers them an orange special—the juice of two oranges over ice with a splash of dark rum! Attractive,

well designed, functional and handy—June's kitchen looks alive even when she is not cooking. "I wish I'd seen this juicer ten years ago, because it's such a joy to me."

Whether you work at home or in an office you want to make it yours, and special. Just as the way you dress expresses your individuality, your workspace should reflect your personality and flair. Have your personal treasures around you, whether it be a favorite paperweight or seashells gathered from your last vacation. Photographs of your children and spouse, even potpourri in a basket can make your presence felt.

Think of your workspace as you do your living room and of how you can make it uniquely yours. Sit in an antique chair instead of an office swivel chair, if that's more "you." Bring a hooked rug to place in front of your desk. Have plants near you and pretty nonfunctional objects on which to feast your eyes. Put your stamps in an antique wooden box. Use a silver George III meat skewer as a letter opener. If you collect baskets, display or use some of them in your workplace.

Treat your workspace with the same reverence you do your living room. Your workspace is solely for you. You have no one else to please. My husband's workspace has been described in a law journal magazine as an elegant flea market—and why not!

A client from Los Angeles enthusiastically reported to me how much more pleasure she has in her kitchen now that she has replaced her old pots and pans with white enamel ones. "They're pristine, fresh, and they match my shiny white kitchen cabinets. They make me feel organized. I can heat up a Lean Cuisine in one or whip up an omelet. They're attractive enough to bring to the table as serving dishes. By simplifying and unifying all my cooking gear I have more energy and fun in the kitchen."

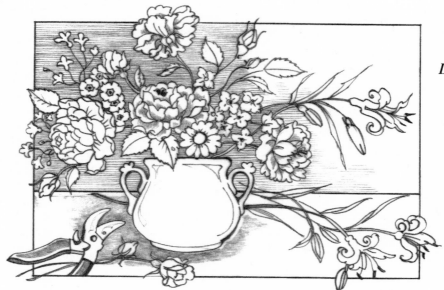

One of the complaints I hear most often is, "I'm bogged down." Or, "There is too much to do! I feel like I'm plowing through." Or, "The piles on my desk are getting so high they're beginning to fall over. I'm misplacing things!" And, "Help me get rid of this clutter!" A writer friend who also runs a big house and chases after two young boys finds color coding the different parts of her life keeps her from feeling things are out of control. Karen uses blue legal-size Pendaflex and file folder for her writing career. Yellow holds her household information: red is family; green is for personal files. Most stationery stores carry these four stock colors, and my friend has color coded her Rolodex too, in pastel hues of the same basic four colors, so she can quickly find her literary agent's name listed on a blue card, and not have to flip through all the household numbers, which are yellow.

The 3-M Company now has Post-It®Note Pads in three sizes—blue, pink, green and yellow, as well as white. These are so handy once you've started a color-coded system, and they're enormous fun to use. You can stick them on anything at whim and remove them without leaving a mark on the paper.

At our office we keep a different colored folder for each day,

Monday through Friday. We buy them at a local stationery store; they're imported from France by Rhodia. These folders, which are called "Primrose Bordier," are ideal for catching mail and all the accumulation of a day's paperwork: the change of colors helps us feel current. Something that isn't accomplished in the Monday pink folder gets put into the blue Tuesday one.

———

A client of mine who lives on a horse farm in Kentucky does all her filing in attractive file and storage boxes that are covered with decorative paper. Inside her file box are pastel folders labeled with her different interests. Her storage boxes are very sturdy, and range in size from 8″ × 11″ × 2½″ deep up to 11½″ × 14½″ × 4″ deep. A stack of five or six of these boxes looks charming and it's so convenient to be able to carry them around wherever they're needed. Mrs. Wilson bought her boxes at The Mediterranean Shop in New York, and has additional boxes sent to her several times a year when they get new patterns in stock. Suzanne's bedroom has these boxes scattered around and they look so pretty—it sure beats a metal filing cabinet for home filing!

I've collected lots of decorative boxes over the years, and find I ritualistically sort through my papers because I can put a box on my lap—no matter where I am, even on an airplane or a beach—and go to work. Because these boxes are solidly constructed, I can also use them as a lap desk. I've learned always to have three or four empty ones around in which to house the next projects. Because they are pretty and colorful inside and out, I tease myself into order and enjoy my storage-box rituals. They are so flexible—you can work on several projects at once, and by keeping them in separate boxes, you don't feel overwhelmed.

My box collection ranges from antique wood to modern, lacquer, marbleized paper-covered boxes, French and Italian handmade paper-covered and cloth-covered boxes. I've also covered my own boxes in colorful fabric and paper, and have saved especially pretty

and sturdy department-store boxes. Boxes can help you organize tasks into rituals. An in–out box for your desk, for example, could be a Pierre Deux French provincial *vide-poche* (empty pocket), measuring 9″ × 11½″ × 2½″ deep. You can select from dozens of enchanting small-scale printed fabrics. They sell a 6″ × 6″ size also, which is ideal for jewelry or change.

Magazines pile up; most of us don't throw them out until we've gone through each one. A soothing ritual is to clip out articles you want to read, or have read and want to save, or cut out pictures that give you ideas. Then store the articles and pictures, and throw away the magazine. Do this once a month at least. I suggest having two storage boxes—one for articles, the other for pictures and ideas.

Then, when you have some time, you can pick up a box you *know* is full of things you want to read. And the fatigue generated by having a lot of magazines around is eliminated.

If there are magazines you want to save—such as art periodicals —use paper clips or ribbons to mark articles of special interest. Magazines can become useful reference tools, whether through articles you clip out or issues you mark and keep intact.

Make a ritual of clipping things of special beauty from magazines; an old notebook can be made beautiful by pasting a garden scene on the cover. I keep a pair of scissors handy in my "visual box" for when I want to cut out pictures. Such a box not only can bring great pleasure through its beauty, it can also bring the pleasure of a happy ritual. I refer to it often to add fresh ideas to my own home rituals.

FILOFAX

I went to visit a friend who was home confined to bed; her bed had temporarily become her office. Scattered around her were papers, books, newspapers—and three address books! I inquired why three

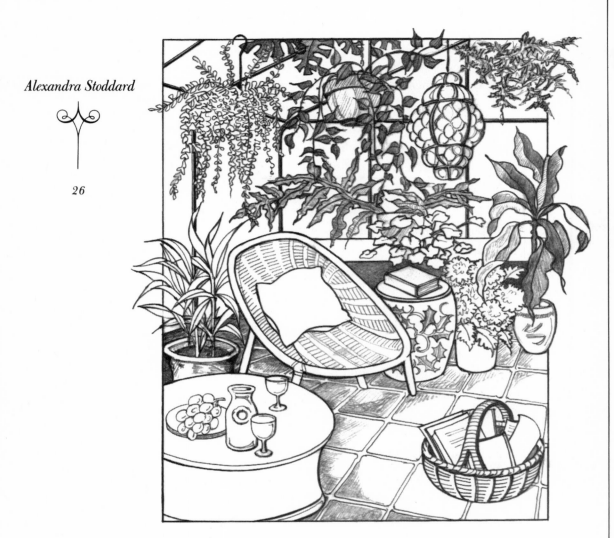

address books, and she sighed and explained that she's never had time to transfer addresses and numbers into the new one, so she had to keep the earlier two handy.

I showed her my Filofax looseleaf notebook; it holds and organizes many details of my life. This small leather book, 7″ × 5″ × 1½″, is designed for a busy person—a place to keep necessary information together, organized and flexible.

I opened my Filofax and showed Cecily: addresses and telephone numbers are on looseleaf sheets; there is a daily calendar, a year-at-

a-glance, blank sheets for your own notes, projects, information, financial records, diary—everything is separated by tabs. There is a place for credit cards, passport, stamps, photographs; there are a variety of sheets entitled "Don't forget," perforated "memo" notes, numbered onionskin sheets for short notes, tracing paper; to top it off as the most quintessential notebook ever, you can buy pure white paper lined in red, plus lined and unlined sheets in wonderful pastel colors—lemon yellow, pistachio green, sky blue, strawberry and lilac, as well as ones in intense, vibrant colors—Paris blue, grass-green, taxi-cab yellow, plum and Matisse turquoise. Fold-out paper in pastel colors is also available, so you can write a letter to a friend on a bus or airplane! The advantage in using the English system of Filofax, or something similar, for everything is that no wasted time is spent transposing information from one small note-book to another. Short-term and long-range planning can be sepa-rated by your own color-coding system, and then filed when you don't need it any more.

Cecily's bed rest was short-lived; she raced out to buy a Filofax, and now she calls it her "brain book." The reason this particular book-notebook system is so ideal is simple—there is a refill for everyone's life's needs, even entertaining and expense accounts. Or you can design your own refills to suit your special requirements. My color coding is cheerful and brightens up whatever project I'm working on. I carry in my Filofax miniature scissors (a necessary tool for a designer), a scale ruler, calling cards, money and my bank statement.

Recording things in my Filofax is a pleasant ritual of order; it helps me plan my days and keep the details of my life organized.

Exercise is, for me, a preordained ritual; I think it's a necessary part of life, and one that should take place without interruptions. Early morning is best for me, but the main thing is to choose a time and stick to it. I store cotton pastel-print exercise rolls inside my bed-

room closet so that as soon as we've brushed teeth in the morning we can get them out and exercise to music. I've discovered that if I escape the bedroom before doing this, I find dozens of distractions and make excuses to myself as to why I'm too busy to exercise!

If you must exercise at the end of a work day, I think it's a good idea to do so before you open the mail, talk on the phone or sip a diet soda. By creating an exercise ritual in your schedule you make time for it because you've saved time for it. You'll feel happy about yourself for carrying out your good intentions.

To provide inspiration for your exercise ritual, cover your exercise mat or roll with a pretty cotton material, sewed on with Velcro so it can be removed easily for cleaning. Take time to put on exercise clothes, because being in proper attire encourages you to take your regime more seriously. Always try to exercise near a full-length mirror so you can monitor your own progress. Exercising at home requires discipline, but once you're set up for it, it can be fun.

———————————

Coming home and shutting the door on the outside world is an experience I look forward to, and I celebrate with something refreshing. Having a soft drink, fruit juice or a cup of tea or coffee as I prepare for the rituals that will follow, both symbolizes coming home and uplifts me. And while I prepare my refreshment, I anticipate having it in a favorite glass, cup and saucer or mug, in my own place. We remind ourselves, as we pause, that being home is the real treat.

In the winter I make a cup of broth. After I return from an exercise class, all hot and sweaty, grapefruit juice and ice crushed in the blender tastes particularly refreshing. I pour it into a huge balloon glass and sip it through a silver iced-tea sipper I inherited from my mother. The gesture is small, yet has a powerful effect on the senses. Offer yourself attractively presented tonics when you come home, just the way you would if a friend were with you. Treat yourself to a brief pause for pleasure and renewal.

The next time you make yourself a welcome-home refreshment, consciously add an extra touch of flair or color to your glass. Garnish clear broth with a sprig of parsley, add a dash of mint or an orange slice to your drink. Experimenting with these touches will not only give you a lift, they'll help you to calm down and take a minute to enjoy a few special moments at home—before you get going again!

When I return from the office I put on an attractive apron and unwind by freshening up the house. Somehow this simple act— putting on an apron—sets the stage for my tidying-up ritual, and I go about the apartment attending to little things. I've collected several pretty aprons in New York over the years—from Pierre Deux, Laura Ashley, The Pottery Barn, Porthault Linen and various department stores. I select one that seems appropriate for my mood and what I'm wearing. By moving about, rearranging objects, stacking books in neat piles, throwing out old newspapers and watering and misting dry plants, I give a personal touch to all that surrounds me. Sometimes the placement of a dish on a table can make a real difference to the pleasure a room conveys. My tidying-up ritual relaxes me.

Samuel Johnson reminds us, "Women have a great advantage that they may take up with little things without disgracing themselves; a man cannot, except with fiddling." Dr. Johnson made that statement over two hundred years ago; today, men are no longer disgraced when they take up little things, too.

Puttering is different from tidying up. Puttering is really a time to be alone, to dream and to get in touch with yourself. When I'm tidying up I can always use an extra pair of hands, but when I'm puttering I like to be on my own. The puttering ritual often flows from the tidying-up ritual—we become lost in our own worlds.

When I putter I make new discoveries; I set aside time for this ritual.

When you are unwinding alone, unpressured, you see things differently than when you are under the gun. I find I have a greater sense of smell, for example, when I am unhurried. I can almost smell the old white paste in my family scrapbook albums and sense all kinds of things. When I putter, I sort through belongings I've gathered around me; I'm reminded of aspects of my life, and the memories are brought into the room. Puttering is a healthy way to sort out where you are at any given time, and for me it's a daily—or at the very least a weekly—ritual.

When you putter your mind is free to make all kinds of associations, and whether you're leafing through magazines you're not yet willing to discard, or looking through a stack of old pictures, you'll discover you're in a fantasy world—one where you're free to let your mind travel to new distances. I rediscovered my great passion for postcards one evening while puttering, and now have produced a book—*The Postcard as Art: Bring the Museum Home.* Plan for this kind of essential, unstructured time alone; give yourself time to become influenced by your private feelings. The smallest gem of an idea can turn into a real jewel, and puttering allows you time and space to develop your concept.

Webster's *New World Dictionary* defines "puttering" as "frittering and busying oneself in an ineffective way." I disagree. To putter is to discover.

Clock lovers run in families. Tony Victoria, a dealer in eighteenth-century French antiques, inherited his love of clocks as well as his collection from his father and grandfather. Antique clocks have eight-day movement, and so Sunday clock-winding becomes a quiet ritual. Tony listens to his clocks, adjusts their balance, once a week. My husband, Peter, collects carriage clocks, and he, too, winds his clocks every Sunday, when he has time to enjoy the ritual fully.

Spontaneous sharing gives life joy. Make it something you do all the time. When you buy new refills for your Filofax, make a small selection to give to a friend who uses the same "system for organized people." If an article in a magazine makes you think of the Stewarts, who are going to Northern Italy next month, give them the article with a note; or pass on the brochure of your favorite restaurant in Connecticut if you think it's perfect for a family who is house-sitting there for a month.

Give from an inner urge the things you have at hand. You needn't go to a store to buy a gift; it is fun to share personal trifles with friends. I was flattered and touched when out of the blue a good friend sent over a small casserole of *boeuf bourguignon,* with a note: "I made a huge batch and wanted you, Peter and the girls to have a taste. Love, Linda."

What we're really talking about is the power of little things, and how they aren't really little at all—they can be joyful acts of love that enrich and ennoble our lives.

I have created a wrapping area in my tiny white laundry room. One drawer houses the colorful necessities to make a pretty package— Scotch tape, stickers, ribbons in an assortment that includes plaids, stripes and polka dots, colored tissue paper and wonderful wrapping paper ranging from shiny pastel tints to flower patterns. I pick up my supplies as I move about—when I see something special that catches my eye, I add it to the wrapping drawer. I bought some unusual paper at the Brooklyn Botanic Gardens gift shop on a recent visit, covered with lovely botanical drawings. Museum shops are excellent places to pick up tasteful papers, small gift boxes and decorative bags. Having everything in one place, where I can sit at a well-lit counter and wrap, helps me relax and enjoy the moments as I create an aesthetically pleasing package. The Japanese under-

stand this delight. They especially enjoy using *furoshiki,* which are large squares of fabric that can be plain or patterned, silk, satin or cotton. The gift is placed on the fabric, which is then tied up in a delicately knotted fashion. These squares of fabric are available in Oriental stores, and are very popular. Even if you're just passing on to a friend a book you've read, wrap it in pretty paper and ribbon. It enhances the act of giving. A wrapped present given "out of the blue" is an unexpected delight, and the pleasure is truly in the giving as well as in the receiving. Beautiful wrappings stimulate the senses, the imagination and the mind.

A short, timely letter can enhance moments of your day: it can be a gem given or received. In my bedroom I have a small antique wicker desk that is uncluttered and neat and is all arranged so that I can sit down and dash off a note or a card to a friend. I've gathered dozens of postcards from trips to museums and have them there along with stationery and notepaper in letter racks. Having the supplies handy helps me keep to a letter-writing ritual, as does having the supplies attractively arranged where I can see them, be inspired and dash off that note. Make it a daily opportunity to communicate with a friend.

When you go to the post office, inquire about their newly issued stamps. I've been collecting pretty stamps for over twenty years; sometimes a special stamp on an envelope can speak as loudly as words: "Letters mingle souls," "Love" or a "Massachusetts" stamp sent to a friend in Boston. Have a generous supply of stamps on your desk or in your letter basket. Our sixteen-year-old daughter Brooke was away all summer; we only received one letter telling us she was alive! When she returned home we teased her and asked why we hadn't heard from her more often. "Writing was fun, I have lots of letters in my bag I never sent you. Finding a stamp was the problem." A variety of stamps, notepapers and cards can make letter writing more efficient and fun. If you are thanking someone for

dinner you might select a museum postcard of a feast. If you send one note a day you'll need 365 a year, so you should collect stationery and postcards as you go along. Have a pretty cup to hold some colored pens so you can have plenty of variety when you sit down to write. The letter-writing ritual should be generously provided for. Sending a surprise letter to a friend is like sending your ship out to sail.

Most of us know some people who live partly vicariously, through *our* activities—people who are elderly or in poor health who need us to cheer them. Someone else's energy and enthusiasm can make their day, while it requires only a little effort on our part. People who are now old may once have made big contributions to us, earlier in our lives, and have asked nothing in return; you can do something for them now. These people may not be able to reciprocate. Reaching-out rituals keep you in touch.

Older people hear how busy we are; find time and ways to make staying in touch an easy and frequent part of your life.

People who keep a daily journal do it for diverse and private reasons. Just as it is possible to gain more control over your life by developing meaningful rituals, so too, keeping a regular diary helps you know more clearly what your thoughts and feelings are, because you've written them down—have put them into words. You learn, by recording your thoughts and pleasures. A diary helps build up the muscles of your personality. For the modest amount of time and discipline it takes to keep a diary, the rewards are tremendous. In truth, those of us who keep diaries cannot stop. Once I'm in the flow I must keep up; like breathing out and breathing in, writing in my diary is a daily ritual. It helps me keep track of myself and my life, and thereby to live more deeply and fully.

Two things help in keeping a journal. First, choose a type of

notebook or blank book that pleases you; second, set aside a time each day when you can settle down and write in it.

The size, cover, smell of the notebook, as well as the color of the paper and its smoothness—these details matter; the more pleasing they are to you, the more likely it is that you will stick to the journal ritual—and enjoy it. Each diarist has to feel his or her own way at first, and then a system will eventually establish itself. Once you find a type of notebook you feel comfortable with, stock up on them —choosing the right journal just for you is the important first step.

I gave our daughters blank books from Finland—red for Alexandra and yellow for Brooke. Alexandra uses hers as a notebook, recording images and ideas. Brooke's book is still blank because she feels it's too beautiful to scribble in—she wants to write a book in

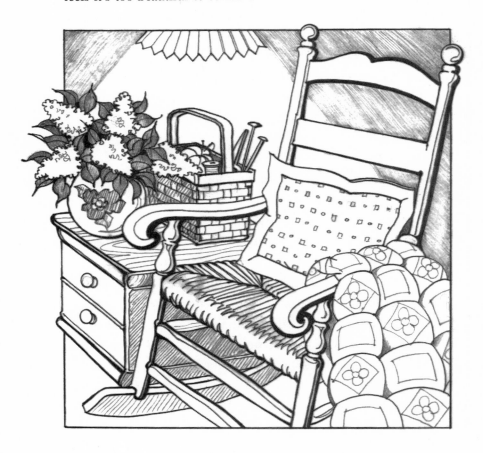

it! If a leather-bound diary seems intimidating, go to a more modest type. Shop around until something clicks.

After you have your blank book, pick a good time of day to write in it. I tend to write my diary in the evening, after I've experienced the day. I can even write on a bus or plane now—once you have the habit, you can do it anywhere; at first, though, I needed a ritual place, and time to be alone, to write. Be alone if you can, because it will make you less inhibited and more able to relax totally, to daydream and fantasize—and to hear what your subconscious might have to say.

Thomas Mallon's *A Book of One's Own: People and Their Diaries* is a survey of diaries kept and published over centuries. Mallon's belief is that all diarists hope to be read someday. After reading Virginia Woolf's diaries, he wrote, "In diaries, as in life, people are much more changeable than they are in novels." When I told Brendan Gill, the author, that I kept a journal, he chuckled, "I admire you, Alexandra. You have to be honest with your feelings. How difficult that must be."

A review of Mallon's book in *The New Yorker* concludes, "The value of diaries—and especially of this book about diaries—is that each unique statement reminds us that every one of us is filled with an unguessable quiddity . . . Each of us is a surprise for everyone else."

———————————

Reading is a habit; I think it should be a daily ritual, like brushing your teeth. Magazines and newspapers tend to get looked at because they are current. But we need to make time for books!

Reading can be like a little vacation, a regular mind-expanding experience that adds up to a lifetime of enrichment. Give yourself a regular time each day, or each week, to read. Many of us read a great deal in our work and want to find escape in our leisure reading. Or, we read to learn. I read for the pleasure of learning, of thinking about fresh things. I am never without a stack of books

waiting to be read. I put the most important ones on the top of the pile and by shuffling through them I find the ones that are most important to me—the less-important books always wind up at the bottom. I keep a running reading list in my Filofax, and whenever a friend recommends a book, I jot it down, then check off the books as I purchase them. There is nothing scientific about it, but I'm never at a loss when in a bookstore; making it a constant ritual to write down the names of books I want to read spurs me on to read them.

Because my daily work schedule is packed full of appointments, it takes me my tidying-up ritual, my puttering ritual, my letter-writing ritual and usually a good hot bath and time to write in my diary before I can settle down, sit still and read for any length of time. During the week I read books in the evening. I have a menu of reading with enough variety to ensure there is always something new to work on. I've made it a habit never to let a day go by without reading a book for at least twenty minutes. Twenty minutes a day of pleasure and stimulation—which add up to several hours a week! I'm always amazed at how much I don't know and how exciting it is to put missing links of information together.

Our oldest daughter, Alexandra, now a college student, shared her summer reading list with me when she was in high school, and together we read some of the classics for the first time. Education extends over our lives, and by reading books every day, as well as articles, magazines and newspapers, our horizons are broadened.

Peter and I buy paperbacks whenever possible, so that we can mark them up without feeling we are vandalizing expensive property. I tend to like to annotate anything I read, because it helps me remember key ideas, anecdotes and passages. I use one color ink, and Peter uses another, and we read each other's books so we can discuss them.

One of the greatest gifts of all is for a friend to recommend a book to you. Word-of-mouth is such as effective way to learn about a book you haven't read. Time is precious, and a suggestion from a

trusted friend can be a great help in selecting the books to focus on. Whenever I read a book, I note in the front of it the date and when and where I read it; I also note the name of the friend who has recommended it to me. This is an easy method that enhances the ritual of reading. A few dozen books get reread several times, and I record each reading. It's fun to remember back to when I first discovered a book!

Keep a dictionary by your chair or bed when you read. "Do it now" applies to looking things up in the dictionary. I keep a pad filled with words I've learned this way and try to use them in my daily speech, so that they become mine. The correct word is like any small detail that's just right—it enhances life.

Think of the accumulation of books gathered over a lifetime. Trying to store them all under one roof would be a nightmare. Weeding out unwanted books is a necessary ritual. Some inexpensive paperbacks come apart, the paper darkens, they aren't pleasing to look at or reread. Pass them on, and make way for fresh new volumes.

Keeping the books we love and passing others on to friends or to the thrift shop is therapeutic. You look at each title and determine whether you want to be its caretaker any longer.

If you have a guest room, it's nice to stock its shelves with a fresh supply of books from time to time. There should be rotation, with some books given away or discarded.

This past year a friend of mine gave away half her books. She simply couldn't rationalize building more bookcases to house books she'd never read again! She got her moving company to deliver twenty-four book boxes and she and her husband went through the books shelf by shelf, ritualistically, looking at each book and placing it in a book carton if she felt the book had served its purpose in their home. Cartons were filled for each of her children, carefully labeled and stored in the attic.

Sally is an avid reader who finds it refreshing to move her books around on tables and bookshelves, exposing fresh titles and offering

new visual treats. She rearranges her books once a month, and claims she and her family are stimulated to pick up new books because different ones are lying around. Change the books in your bedroom and bathroom from time to time. Many have pretty jackets that add color and texture to a room and can be powerful symbols that inspire you to think about new things.

Sally made her books even more pleasurable to herself by creating her own bookplate; she Xeroxed an old engraving and cut it to size. You could have any design printed for your own bookplate. Museum shops also sell attractive, colorful bookplates that are preglued. Sitting by a fire and putting your personal stamp on books you love can be a rewarding ritual.

Leather-bound volumes require wax to keep them from drying out, but I wipe off the dust jackets of regular books with paper towels and liquid household cleanser.

When you put books back on the shelves, group them by category; put reference books, art books and novels in separate sections. We have one shelf for books written by friends, and another for especially treasured books. When I need inspiration I can browse in these sections and be among good friends. We read favorite books over and over—and I place a piece of striped grosgrain ribbon in the page or pages of very special passages so I can easily open these books to my favorite sections. Most of us have a few dozen books that really influenced us, and it is a comforting ritual to house them all together.

A generous stack of illustrated books makes a wonderful low table on which to place your eyeglasses. I often make a ritual of thumbing through several picture books at one sitting, so I keep a stack next to the swivel chair in the living room where I like to sit.

A useful and liberating daily ritual is the morning list. Before I leave the apartment, I make a quick stream-of-consciousness list of the things I need to remember to do. Everything that comes to mind, from notes to write to phone calls to make to tickets to pick

up, goes on my morning list. Mine is written on a "don't forget" page in my Filofax. Peter writes his on a corner of the New York *Times*. Use whatever system works best for you. After a night's sleep, random thoughts pop into mind and this list helps you gather together all the stray concerns that need to be remembered. My lists are dated, and each thought is numbered from one to twenty-four. Some mornings I only have three or four things to remember and other times I worry I'll have to go on to a second "don't forget" sheet. This listing ritual calms me and allows me to finish reading the New York *Times* in peace, sip my coffee and savor the last moments at home in the morning before I leave for the office. Also, once I've written out a list, my mind begins to go ahead and "solve" the problems. When I come to actually "do" the things on the list, I often find I have more original ideas of how to go about accomplishing the tasks—because my list-making ritual started my mind working on the solutions.

Residential interior designers engage in a highly personal and often close and friendly relationship with their clients. Our job is to help set up houses and apartments for *living*. One of my clients, Jeanne Crawford, called me from Washington. "I'm really upset. For twenty-five years I've used a certain type of leather scrapbook for my pictures of family and friends. I called to reorder some this morning and found they've discontinued that model!" This was a real jolt for Jeanne, because she had been arranging photos of her life neatly and systematically, and now she felt frustrated that she couldn't continue. The result was a search for a new type of scrapbook that she would like just as much.

Pierre Deux, a store on Madison Avenue in New York, came to our rescue. They sell scrapbooks covered in patterned cotton, and Jeanne found them so cheerful that she now makes it a ritual to arrange her photographs. She hardly misses the old brown and

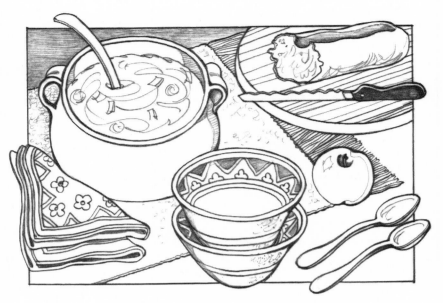

black leather scrapbooks she used to use! In truth, the gaiety of the different cotton materials conjures up her past in Provence, so she keeps them out on open shelves in her family room, where everyone can look at them.

Taking pictures and preserving them in attractive scrapbooks and on slide carousels can become a wonderful family ritual, and it helps you maintain good personal records of daily or special family events and trips.

Make a ritual of having a family picture taken once a year. My mother made a separate scrapbook of these, and of each family trip, mounting the photographs on black paper with white corner tabs to hold the black-and-white pictures, and labels in white ink. When I was a child, I used to sit by the fire while Mother worked on our family scrapbooks, and I still remember it.

Baby books are lovely, too. Our daughters, now teenagers, like to look through their own baby books, and mine, too, as well as my mother's and father's albums, and our own family scrapbooks. It's a good idea to label every picture, and date them—one forgets details otherwise.

Have a supply of empty boxes (shoe size) to put your photo-

graphs in until they can go into albums. Stationery stores sell these in bright primary colors as index-card boxes.

A storage box should be set aside for each newborn baby or grandchild. If you are sending a baby present, a nice idea is to place it in a large reusable box—one that can store locks of hair, hospital bracelets, birth telegrams, first birthday cards and the child's first hand- and footprint in plaster. I have a friend who has saved her daughter's first pink-smocked dress. Having all the sentimental memorabilia—artwork, love notes—in one special box allows you to keep track of and also rummage through wonderful things you don't want to part with, things that wouldn't fit into a baby book. Save the headlines from the newspaper on the day the baby was born.

Another way of preserving family history is to select a wall in your home for framed photographs. My husband, Peter, has framed photographs of his ancestors, family and friends on one entire wall of his office—floor to ceiling; he can look at the faces of all the special people in his life every day. A relevant newspaper clipping goes into an acid-free paper pouch, taped to the back of the photograph.

Part of the ritual is sharing these sentimental pictures with friends and family.

We often remove a picture from an album, have it duplicated and framed (photo-processing companies can duplicate a picture and blow it up without requiring the negative), and then we put the original back in the scrapbook. Have a few prints made so you can send some along to interested family members.

For my daughter's sixteenth birthday, we surprised her by blowing up a large selection of pictures and putting them in a special sweet-sixteen album.

When I have pictures developed, I date the pouch the negatives are stored in and make a few notes about them—a trip to Bermuda, or a special birthday—then file them chronologically in colored index-card boxes labeled "negatives," and dated. One rarely goes

through old negatives, but when you want to reproduce a lot of pictures it saves money to use your own. Every few years I make a ritual of flashing them on my light box and weeding them out—I tend to save most negatives of my family, and only negatives of really spectacular travel photos.

WEEKLY RITUALS

FLOWERS · Flowers nourish a home.

Once, when I was an art student on a tight budget, I deliberately skipped lunch so I could afford to buy an inexpensive yet fragrant purple hyacinth. Buying, arranging and tending flowers is a ritual that enhances our lives.

I buy flowers for our home on Fridays, and for our offices on Mondays. We budget for them, and buy what looks freshest and most colorful. I stay away from iris and other flowers I don't think will last a full week. There are many florists who will deliver seasonal flowers each week at reasonable prices, if you don't have time to go pick out your own.

Part of my daily puttering ritual is to renew the water in the vases, pinch off sad blossoms and cut down the stems, sometimes necessitating changing the vase to a smaller size. I enjoy rearranging bouquets and then placing them in new locations around the apartment. I now have two sets of flower clippers because I find I'm not the only family member who enjoys tending flowers, and this can be shared time. Just as I need to make arrangements for marketing each week, flower-buying is a ritual I look forward to. I do it every Friday on my way home from the office.

CLEANING · A friend once turned me down for dinner because she said she had to stay home and do the laundry! Things like laundry should not get in the way of what could be a special time. Do it while you're tidying things, as part of keeping up with each day, so you don't feel bogged down. By making the laundry a

cheerful ritual, you're free to go out to dinner. Try to incorporate washing and ironing into the work week, so you don't give over an entire Monday to it, or, if you go to an office, a day from your precious weekend.

Saturday is the only day of the week I am unhurried and the only day I don't set an alarm. My body clock awakens me naturally, and I let the morning unwrap quietly. This block of time is my treat— I've gotten through the week and have no early appointments, no pressures. I read in bed, and eat from a breakfast tray I set up the night before. I write in my journal and I daydream. There is a certain moment, finally, when I feel an urge to get up, and I spring out of bed full of energy in anticipation of our one fully free day a week. Saturday morning in bed is a ritual I look forward to, now that my children are grown. I look forward to it, Monday through Friday, and relish it on Saturday mornings.

It's a good idea to build variety into your daily and weekly rhythms—times and days when you deliberately create a change of pace, do something different from what you do ordinarily. Saturday morning is one of those times for me.

There is one time in the week when many of us seem to have the inclination to take a nap, and that's Sunday afternoon. At camp, when we were growing up, we were made to lie on our beds and be quiet for an hour every Sunday afternoon. I find I squirm a lot less now than I did in those early days—a Sunday afternoon of quiet is an enormously restorative experience. I put a quilt or a throw over me and begin by propping myself up against several pillows; then I read magazines. My mind drifts and I doze. Something like this is special because you don't do it every day; it's a weekend ritual.

Sunday night is the last opportunity to be together as a family before everyone goes off in independent directions for the new week —work, school, sports and meetings. Making a special event of Sunday-night supper can contribute to a sense of continuity, of staying caught up with one another. Many of my friends go out to a

neighborhood Chinese reataurant with their family for Sunday night supper, but I enjoy having Chinese food sent in, especially when the weather is bad. Or I fix a simple dish everyone likes. It's informal, but it's a family date that helps us face the rigors of the week ahead.

MONTHLY RITUALS · Life involves an accumulation of waste and clutter—we must clean out the excess baggage in our lives on a rational and regular basis. I'm reminded of the Greek myth of the Augean stables: Augeus, King of Elis, had a stable containing three thousand oxen that hadn't been cleaned for thirty years. Hercules cleaned the stables in a day by diverting two rivers through them! Make a regular ritual of order.

We've all had moments when we've wished for more rainy days in our lives, so that we could have time to put everything in order. Thank heavens, we'll never literally have enough rainy days, so we have to set aside blocks of time to do serious ordering of things— filing, cleaning closets and drawers, even sorting out the toolbox. There comes a time when you must take action; make a ceremony out of serious straightening up. Plan for it.

At our office, once a month, we have one day with no outside appointments and we attack our files, clean up all the clutter and create order. It's a necessary ritual that brings enormous rewards. We play music which soothes us.

At home I make this kind of attack on one area or another of our apartment at least once a week—a few hours of chaos and suddenly you feel exhilarated, just from throwing out. You find things you thought were lost forever. You make new discoveries. A regular, serious attack on mess and unnecessary clutter, performed with a glad heart, makes you feel in control of all the parts of your life you care about.

I heard on the radio this morning that this is "desk-cleaning" week! Ritualism has always been associated with desks, because we write and try to think at our desks. John Edgar Wideman wrote a

piece for the New York *Times* called "The Language of Home," and said: "The setting is crucial. Like most writers, I observe rituals. A meticulously arranged scenario, certain pens, paper, a time of day, an alignment of furniture, particular clothing, coffee cooled to a precise temperature—the variations are infinite, but each writer knows his or her version of the preparatory ritual must be exactly duplicated if writing is to begin, and prosper. Repetition dignifies these rituals."

Begin your desk-cleaning ritual by clearing everything off the top of your desk; I do this monthly. Put all your things on trays. Wax and polish your desk surface. One by one, clean and polish the items you put back on your desk top. Try to put back half of what you took off. Remove each drawer, empty it into a large tray and wipe out the inside of the drawer. Often you will find treasures hidden behind the drawer, so use a flashlight and inspect. A clean slate at your desk can give you the energy to tackle more work more happily.

Intellectual work requires patience. Balancing mental effort with physical exertion is soothing—it releases stress and tension. Of all the necessary tasks to be done at home, polishing—because of my impatient nature—is my favorite and it has become a sustaining ritual for me. I sometimes talk on the kitchen phone while I'm doing it, too.

I can see results instantly—from dirty and dull to shiny and gleaming. I find polishing silver, brass and wood most satisfying. It is the rubbing that makes the difference. There is something rewarding about seeing the tarnish come off on the cloth. Rubbing and stroking objects you love can be a pleasant ritual; turning a dull object into one that smiles back at you gives you a sense of satisfaction.

Group your small brass and silver pieces into categories before you start to work. When you put your newly polished treasures back, move them around to different places. You will appreciate something more if you see it in a new context.

SEASONAL RITUALS · For six months of the year we make a ritual of laying and lighting a fire in the fireplace and sitting around it in the evenings and on weekends. We begin our fire ritual on the first really cold October day. We have swivel chairs on either side of our fireplace, with a reading table in between, and we tend to sit and read, talk and relax, and gaze into the flames. We keep our apartment cool in the winter so the warmth of the fire brings us all together. We often move the books off the round French vintner's table and eat supper in front of the fire with our daughters.

My first memory of visiting my godmother in Framingham, Massachusetts, when I was five, was sleeping in the guest room in a high mahogany four-poster bed that faced a beautifully carved mantel; there was a crackling fire in the fireplace. I felt so utterly grown up! Next to the hearth was a shiny brass bucket full of pinecones that had been dipped in wax; the cones release reds, greens and blues into the flames. I can still remember the crackle and the woodsy, smoky smells, and the heavenly feel of cool sheets and the creak of the bed as I looked across at the grown-up fire in my bedroom.

After Christmas, cut up your Christmas tree branches into hand-

size sprigs of pine and store them in a huge wicker basket by the fire. A few bunches tossed into the flames makes a wonderful crackling noise and smells heavenly. Throw a few orange peels into the fire to make you think of a Florida citrus grove. Santa Fe, New Mexico, smells of piñon wood, which is burned in all the fireplaces in the town. I bought some piñon incense and burned a small cone while I sat by the fire, and it transported me to Santa Fe, bringing to mind all those nice memories of a trip to the Southwest.

A mother amused her eight-year-old son and his friend recently by sitting in the dark in front of a roaring fire reading a ghost story by flashlight. The boys stared into the fire in total fascination.

Twice a year, when the temperature changes, sort through your clothes (and help with your children's clothes); make it a pleasant ritual because you are making way for a new season. Eliminate everything that is no longer useful to you—things that no longer fit you, your current needs or your sense of personal style. For best results try everything on, looking in a full-length mirror. By doing this ritualistically twice a year you save daily time and confusion, and you make it more likely that the things you wear will flatter you now, and make you feel attractive.

Some experts suggest that clothes we haven't worn at least once a year should be given away. Others suggest you weed out one piece of clothing for every one you purchase. We tend to save, and, if we aren't careful, our closets become choked. Children outgrow their clothes from one season to the next. Mark your calendar for these semiannual attacks on your family clothes closets. The linen closet needs the same regular attention. Thrift shops will pick up your discarded clothes and send you a tax receipt. Shelters need blankets and sheets. In helping yourself to gain space, you also help others who are in need.

After your clothes are in order, attack your children's toys. Ideally this ritual should be done every four months. Rotate toys and put some away. The police department and hospitals will gladly receive any used toys as long as they're clean.

THANKSGIVING · Thanksgiving is one of my favorite holidays: first, it is an American tradition and second, you give thanks and count your blessings. Americans gather the family together and celebrate. So far commercialism hasn't ruined Thanksgiving, because this is a day of giving, not getting. Thanksgiving also reminds me to continue to share this same spirit at other gatherings and meals—giving thanks for what we have instead of dwelling on what we don't have. Shirley MacLaine in her book *Out on a Limb* says we should overwhelm the negatives with positives, and I agree.

FAMILY CELEBRATIONS · Family gatherings are often designed around a special event—a birth or a death, a birthday or an anniversary. And sometimes there's an urge to incorporate into these occasions many of the same rituals our parents and even grandparents enacted. The carving of the roast, the ritual of grace or hands around the table with each person squeezing the hand of the next person, the ritual of decorations; who gets the first piece of cake, who makes a wish, a toast, who sings a song. These gatherings can't happen every day, yet we treasure such moments as truly special events which make up the five percent of our lives I mentioned earlier. While you can't save living just for these moments alone, when they do happen the rest of your life is touched.

There is nothing unique about families getting together to eat, drink, laugh and cry. But what is unique is *how* they celebrate. Naturally you will be largely influenced by the way you were brought up and you will have specific traditions you will want to perpetuate. But you can also make such events and rituals uniquely your own. You will dream up ways to bring happiness to those you love as an extension of your own dreams.

ANNUAL RENEWAL · Make a ritual of preparing for a new year. In November or thereabouts, get refills for your date books for the

new year. Properly planned, the transition from the old to the new year can be smooth.

Use the last days of the year to think about how you can make the new year better. Your checkbook begins a new page and your last year's stubs can be filed along with your bank statements. File all your tax information and label it with bold markers. One way you prepare for the new year is by putting the old one to bed.

New Year's resolutions should include rituals that will put the old year behind you so you have "space to breathe" for the new year. When I was in Japan, I saw empty storage shelves in a house in Kyoto; I asked why they were empty, and I was told, "space to breathe." At year's end I clean out my files, at home and at the office. I am happy when I begin a new year with a few empty file drawers and space on a shelf or two. You need to clear a space for the future.

Begin the new year with firmly established rituals, which are also symbolic of a fresh start, of room to grow.

The calendar can't tell you when the first day of spring is—your heart does. Suddenly, the sun sparkles through windows that are less than clean, the air is fresh outside and you want that bright, clean feeling inside your home, too. Suddenly, you attack where you live with a well-known condition commonly referred to as "spring fever." Most of us get it at least once a year, and you should plan ahead for it, by having time set aside and strategic supplies at hand.

Spring begins with the vernal equinox and ends with the summer solstice; equinox is the time when the sun crosses the equator and day and night are everywhere of equal length—about March 21 (vernal equinox) and September 23 (autumnal equinox). One of the great blessings of seasons is change, and after a cold, damp, dark winter, spring seems a magical gift, and it is worthy of celebration. It symbolizes new birth and renewal. And so the first day of spring seems to me a great excuse to give a party. Plan it in the

winter and have the theme be springtime, a garden, and let your imagination go from there. Serve springlike things—mint juleps, peach daiquiries, raspberry champagne, kir, fresh homemade lemonade.

Your everyday rituals will satisfy your human need for creature comforts, visual pleasure and mental stimulation, but there will still be times when your spirit lags, when you feel bogged down, when problems seem overwhelming. Usually this occurs in the darkness of the winter solstice.

A married couple with two demanding careers—a television producer and a journalist, who are raising two small children, four and six—have made an annual ritual of escape. When life lost its color they would hire a babysitter and go to a luxurious hotel in the town in which they live! No frustrating travel plans, no surprises, because no one but the babysitter knew where they were. Two days was enough time to feel refreshed. They were a few minutes from home and were able to use the money and time they saved "getting somewhere else" to go to the theater, have dinner out, enjoy room service and live carefree long enough to get back in balance.

It's important not to take life too seriously, especially all the time. When you're away from clients, friends and children, it is easier to be frivolous or romantic. A weekend away alone, or together, enables you to let your hair down; it might be one of your greatest vacations. The secret is to hole up in the city (or in a country inn) near where you live. The word "vacation" comes from the Latin *vacatio,* which means freedom, release from occupation, to be empty, free. Expensive, time-consuming travel is not always necessary. Make an annual ritual of a weekend escape.

GRACE NOTES

- "Do it now."
- Treat yourself to a massage. It can be equivalent to a long nap, in terms of refreshment; it not only gives you energy, it calms your

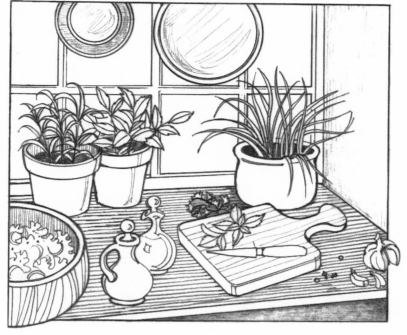

nerves, releases stress and makes you glow with a feeling of well-being.

• Line your drawers with scented Porthault flowered-paper liners, to bring your garden inside.

• Mirror a wall between two windows to bring in more light and give the illusion of more open space.

• Use antique brass weights as doorstops. They're heavy and decorative.

• Buy multicolored paper clips and color coordinate them to what you're clipping. If you find solid-colored paper clips, buy three favorite colors and mix them together.

• Buy pastel-painted paper-cutting scissors made by *Plus* in pink, mint and periwinkle-blue epoxy-coated stainless steel to have on hand—by your bed, at your desk, in the kitchen and at the wrapping area to inspire you to cut out an article, wrap a present or cut out pictures from magazines before throwing them out.

• Have your favorite book bound in leather (Asprey in New York

does this). You select the hide, the color, the endpapers, the tooling and lettering. Make something you love a lasting pleasure.

• Find the kind of fountain pen you like best (I like Waterman). A fountain pen makes the process of writing pure pleasure. When at your desk use an inkwell, and when traveling, use cartridges. Collect different colors of ink to be used as your mood dictates.

• The Finnish architect Alvar Aalto designed a fluid crystal vase that is both classical and modern in its free-form design. It is made in clear or white glass, in three sizes, and it will enhance the beauty of your cut flowers.

• Buy your clothes staples—stockings, underwear—twice a year to avoid wasting time. When you find the right kind, invest.

• Catalogues are wonderful source books; you get an accurate description of the item, a picture, the size and price. Companies with catalogues mail merchandise anywhere. Collect museum catalogues, especially; spot well-designed household necessities and support the arts as you buy.

• Save old, worn-out white gloves and wear them as silver-polishing mitts.

• Use an attractive letter opener. It helps to make mail-opening into a pleasant ritual. Be sure you have a wastebasket next to you! I use natural wicker baskets.

• Place white birch logs in your fireplace during the months of the year when you don't light fires. In summer, keep a wicker basket there, filled to the brim with field flowers. The focal point of a room shouldn't be gloomy.

• Buy wax-dipped pine cones to create bursts of color when thrown in the fire. Stock up around Christmas time for the months ahead. Throw orange peels in your fire for a spicy aromatic twist on a cold evening.

• Put colorful stationery in the pigeonholes of your desk. If it has a high top, open the doors to it and arrange attractive plates and objects inside.

• When you're just about ready to throw away your cologne, put

the bottle in your lingerie drawer to give you and your clothes a lingering fragrance.

• Make old potpourri come alive with some refresher oil. Add cinnamon and orange peels for extra zest.

• Use scented shoe pillows to keep your shoes in good shape and sweet-smelling.

• Store out-of-season sweaters in clear plastic zip bags and put a deliciously scented soap inside to keep them fresh.

• Pamper your wardrobe with satin-covered pastel hangers for suit jackets, silk blouses and silk dresses. Spray hangers with your favorite cologne.

YOUR OWN GRACE NOTES

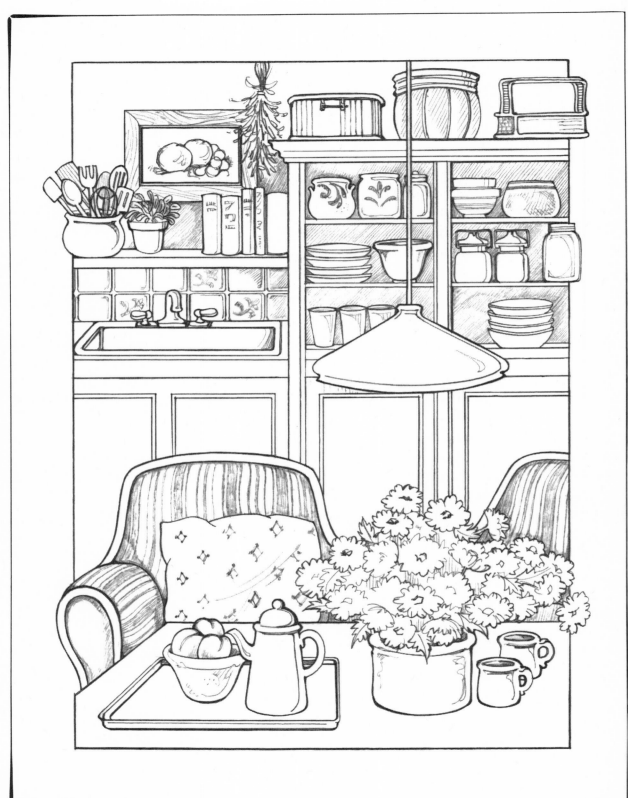

CHAPTER 3

THE KITCHEN: ENHANCING THE FLAVOR OF GOOD EATING

*A*rchitect Frank Lloyd Wright said, "Dining is and always was a great artistic opportunity." Yet all too often we elaborate on menus for guests and skimp on our own everyday dining rituals.

The more carefully we plan our meals, the less tempted we will be to overdo in quantity.

Meals are small acts of great importance, moments set aside for conversation, reflection and communion. I think there should be a high concentration on the ritual of eating. Beauty has no calories and yet it improves your health. One of the saddest things in life is the loss of opportunity—what might have been. Make the effort to create meaningful ceremonies at mealtime. A little extra work might be required to bring a trolley or tray outside so you can dine under a tree, bring a cookout down to the beach or set up a card table by the fire, but the rewards are memorable and lasting.

Last summer Peter and I were in the South of France and spent a few days and nights at Baumanier at Les Baux. Baumanier is one of the great four-star restaurants in France, and one of the greatest country eating places, situated south of Avignon in Provence. This

beautiful spot, built into huge, dramatic rocks left over from the Ice Age, and shaded by tall pine trees bathed in Mediterranean light, makes eating out of doors like living in an Impressionist painting. After being there, I understand better what peak experiences are, especially in the context of food rituals.

We can't all go to Les Baux—and we can't live in luxury every day of the week. But I learned a lot at Les Baux about how careful details contribute to the beauty of life, and the pleasure one can get from a meal.

One day the chef at Les Baux came to our table and said, "Come, come. Follow me." And he led us into the great kitchen.

What struck me there was the impeccable attention to detail, and the wonderful organization. The young chef, Jean André, was in the center of the kitchen, arranging salmon and sole on a plate. Behind him were dozens of little white dishes containing berries of all sorts, herbs, slivers of blanched vegetables, peeled cherry tomatoes, truffles and caviar.

If I were to list the ingredients that went into just one of the salads I was served for lunch at Les Baux I would be criticized for making the recipe sound too difficult. Yet Jean André's special salads are aesthetic feasts—you hesitate at first to destroy the decoration by eating them! Beauty has a powerful effect on our appreciation of the eating ritual.

Details—finishing touches—are so important in creating special eating rituals, rituals at which all our senses are brought into play. Eating is the ritual of communion; over a lifetime, it gives us opportunities for a continual flow of creativity, and for unique personal expression—a chance to delight and nourish the spirit as well as strengthen the body. The attractive way you set the table can also set the tone for a meal, and gently yet powerfully convey affection, warmth and caring. These things all arise from love and from subtleties, such as the special way you fold a flowered napkin or the way you garnish a platter of roast chicken with slices of lime, lemon, orange and watercress.

Home is the extension of our essence. Home is what we make it. Shakespeare was right: "When I was home I was in a better place." When Charles Dickens traveled to America, he wrote to his best friend, the English historian John Forster, that famous line, borrowed, I suspect, from John Howard Payne's "Home! Sweet Home": ". . . there's no place like home." All the rituals we perform at home are done to express our feelings. We can't care enough. Nikos Kazantzakis said in his autobiography, *Report from Greco*, "Since we cannot change reality, let us change the eyes which see reality."

Kazantzakis felt that the process of living, the touching of the human heart, was something not so much to attain as something to be shared: "Never halt in the ascent." Each day, through the eating rituals we create, we touch the human heart.

Sense stimulation helps keep us cooking creatively, meal after meal. Kazantzakis, who also wrote *Zorba the Greek*, referred to the five senses at "the five doors." Flannery O'Connoor observed that "learning to see is the basis for all the arts except music." Another writer I admire believed it was music—and said, "Music is the fourth great material want of our nature—first food, then raiment, then shelter, then music." Beauty nourishes. And food feeds all our senses, as well as our bodies. Our eyes and our noses are especially essential in the eating ritual.

So touch it. Picking up a fresh strawberry by its stem and dipping it into powdered sugar satisfies my hunger to touch, lick, use my fingers the way I did as a child. But before I taste, touch and smell, I see.

Throughout history, food has been a subject for artists to draw and paint. A platter of cold, cooked asparagus whets one's appetite for spring. The sizzle of butter in a frying pan is music, too. The smell of freshly brewed coffee warms hearts. The aroma of the garlic in escargots makes mouths water. One perfect pear on a dessert plate feasts the eye. The taste of midsummer corn on the cob dripping with sweet butter and sprinkled with ground pepper

reminds me of every summer of my life, and the delight of the moment is intensified through memory.

All our senses come to a peak in the ritual of eating. We need to eat for health and strength; we spend about twenty hours a week in the process. The art of eating is, fortunately, to a large extent in your control—what you put into your mouth, where you eat, when, how much, how and how often is in your hands.

We remember most fondly those aesthetic experiences that have unity—meals that are attractively presented as well as superb taste treats, that are complete in themselves. Not "just a meal," these special experiences give daily life quality and resonance. High color contrasts, textural changes—from the crunch of snap peas to the richness of a velvety lemon mousse—the quality of light around you, the plates used, the temperature of the food, the setting, the smells, the crystal, the sparkle, the shape of the gleaming fork, the fine lip of the glass, the garnish, flowers—all these add to the incomparable pleasure eating can be. No matter how good a cook you are, the presentation of the food and the setting of the stage is a large part of the art of eating. I am persuaded that we can be satisfied with fewer calories and maintain a proper body weight if we indulge in thoughtful meals that are also celebrations. To short-change your choice of food and its presentation in your daily ritual of eating is to shortchange life.

The old adage says you are what you eat. I think there's truth in this. When we eat properly, we feel better. Our physical and mental health improves when meals are presented in a way that encourages us to relax. In a recent executive health report on psychoneuroimmunology (the study of how the mind influences health), Drs. Joan and Myrin Borysenko concluded that "personality and attitude are translated into physiology that can either maintain health or engender illness." They and others advocate maintaining "wellness" of the mind as well as of the body—to cope with stress (which they believe in modern man is largely mental) and to learn to relax.

The *way* you create eating rituals will influence your "wellness."

Most of us know the importance of taking time, of slowing down occasionally during the day, to relax. One's eating rituals can keep an active, full life in balance.

By the time you have reached your fortieth birthday, you will have eaten about 50,000 meals and spent over 50,000 hours in a food-related atmosphere! We have to eat to live, so why not make it one of the simplest pleasures in life—beautiful and memorable, as well as delicious? I believe the quality of the food we treat ourselves to and the elegance of the food ritual sends out a signal about how important we think we are, a signal to our inner selves and to others. Proper and aesthetic eating habits are a strong clue that you appreciate yourself and, in turn, can appreciate others.

I've found that the essentials to a pleasant eating experience, in addition to what you eat, include: (1) good company—which can be yourself, (2) the setting, (3) the fact that you don't eat too much and (4) recognizing that you have to be hungry before you begin. Lord Greville—Sir Fulke Greville, the early English court poet and friend to Queen Elizabeth I—suggests:

May not taste be compared to that exquisite sense of the bee, which instantly discovers and extracts the quintessence of every flower, and disregards all the rest of it?

And finally the great nineteenth-century French gastronome and philosopher, Anthelme Brillat-Savarin, states, quite bluntly, "Animals feed themselves; men eat; but only wise men know the art of eating."

The kitchen is often the heartbeat of a home. Its palpitations should whet your appetite for life. Good smells from the kitchen give homelike comfort to adjoining rooms. Years ago, when I was a young mother with two small daughters, a wise older woman friend told me that a house only becomes a home when good smells come from the kitchen. This observation came to life for me when I later visited her in northwest Texas. I smelled apples cooking as I was

greeted at the front door. "Welcome," my friend said. "You're smelling homemade apple tarts in the oven." During my stay I enjoyed kitchen smells all the time; they floated through the house: roast leg of lamb with garlic, baby chickens roasted with herbs, broiled stuffed tomatoes with thyme, stewed rhubarb, lemon tart and roasted almonds. No matter what the time of day, there was always something mouth-watering to smell. From freshly roasted coffee in the morning to cookies in the early evening, that house was alive with new smells, new life.

I know an extremely successful career woman who leaves beef bones simmering on top of the stove at home while she's away at work all day. When she turns the key to her apartment at night and smells beef stock, she becomes spirited enough to begin to prepare a delicious dinner.

In cold weather, simmer apple cider, cinnamon, cloves and tangerines to make your house smell cozy. I have a friend who pops popcorn at 3 P.M. five days a week. At 3:06, her two small sons race home from school with their friends and devour a huge bowl full of popcorn. To this day Karen is convinced the boys smell it all the way from school!

Many of us are drawn to our kitchens like birds to their nests. Of all the rooms in our lives, the kitchen can feed the soul and become a comforting place to be at any time of the day. I think of the kitchen as a gathering place, a place for shared comforts, for mutual efforts at preparing good meals with loving care. One's kitchen can become a place in which to confirm your love of life.

You can tell a great deal about a person by visiting his or her kitchen. Your kitchen is important to your sense of well-being, and as expressive of you as your living room. Even a tiny kitchen can be organized effectively and beautifully.

Using a gleaming copper kettle to heat up water to pour over freshly ground coffee beans for morning coffee is an opportunity to please your senses of sight, smell, touch and delight. Home is where we go to be most ourselves, most fully in tune: it's not a place where

one should turn off the senses but rather where one should turn them on. Everything counts, because we are so open to influence. By concentrating on the aesthetic elements of your kitchen with the same focus you bring to the practical, you will create in it a sense of wholeness, and of the personal. Like all other rooms, kitchens should reflect your personality and your love of life.

Samuel Johnson said, ". . . little things mean everything . . ." Perhaps this is elementary, for even Sherlock Holmes observed, "It has long been an axiom of mine that the little things are infinitely the most important." So the kitchen is our message center; we have a rack there on which to put all messages, and everyone in the family knows where to look for information.

Three basic elements in interior design that bring atmosphere and charm into your kitchen are: Keep it simple; make it appropriate; make it beautiful. It sounds so easy—simple, appropriate and beautiful—yet you need to be watchful to accomplish it.

One of the best ways to make your kitchen more human is to grow plants there. If you have the space for it, build a ledge under your kitchen window. A 12"-deep ledge can hold geraniums, white narcissus, pots of herbs. If your window opens inward, make the ledge low enough so that the window doesn't interfere with your indoor garden. A ledge under the window is also ideal for ripening fruits and vegetables.

Plan your kitchen as though it were the galley of a boat—all functional gear stowed away when not in use, so that you're not bogged down with things that are irrelevant. Set out just what you need for cooking and serving. I find this discipline and domestic order soothing as I begin my work in the kitchen.

The telephone is off limits during meals, but I often catch up on phone calls while rinsing spinach or making a sauce. Measure out your kitchen and determine how long your kitchen telephone cord should be, so you can open the kitchen door, reach into the refrigerator, get to the sink and dishwasher and reach spices and bowls while you are on the phone. My kitchen telephone cord is eight feet

long. The phone company will change your cord for a nominal fee. If you make a lot of calls while cooking, perhaps your kitchen phone should have the dial located in the receiver, so you don't have to be restricted while you talk.

Kitchen counters are your staging areas, yet most counters are too low. You can raise your kitchen counters as much as two inches quite inexpensively, simply by installing a slab of butcher block over your existing counter. To hide the crack between the two different counters you can glue on a decorative ceramic tile border, or make an apron of maple on the front edge of the counter.

Freeing counters of equipment gives you more working space, and creates spare, clean areas on which to display attractive objects. Look at your countertops as settings for beautiful, constantly changing still lifes.

Take everything off your counters and think about what you have. What appliances, what decorative pitchers or bowls? What things do you use every day? What do you use less regularly? Keeping these factors in mind, create a picture on the countertop.

If you have wall space above the splash back of the counter, you could open up the space and add sparkle by having a mirror installed that fills in the whole space from splash back to cabinets.

One of my clients built his wall cabinets down to touch the countertops, so he can stow all the usual countertop equipment behind closed doors. The countertop is eight inches deeper than average, so all the purely functional gear can be hidden as well as handy. He even has the electrical outlets inside the cabinets. The toaster oven, blender, juicer and electric knife sharpener are available for instant use but don't clutter up the clean lines of the kitchen.

I like to mix silver- and gold-colored metals in kitchen equipment. Even if your appliances are chrome, it adds a warm and attractive touch to have brass knobs on the cabinets. A copper bar sink with a brass water spout mixes happily with a stainless-steel sink and dishwasher.

By using a sturdy old farm table and chairs, you can bring the feel of the country to your kitchen, wherever you happen to live. It is difficult to hurt an old wooden surface, because age and use give it character and patina. If you don't have a set of old chairs, collect several old brass milk cans for extra seating—they're remarkably comfortable, and take up little space in a kitchen.

An oversized clock in a kitchen is nice; it can be seen from anywhere, whether you are baking or watching a soufflé or checking to be sure your child leaves for school on time. We have a brass ship's clock with large numbers and a red second hand.

Kitchen walls don't get as greasy as they did in the days before modern ventilation. Hang lithographs and paintings there, where you'll be able to see and enjoy them. Canvas can be easily cleaned with mild soap and water and glass may be polished with liquid glass cleaner. One of our favorite paintings, by Roger Mühl, of a barn in the South of France, is over our kitchen table. Hang baskets among your pictures. I'm a basket collector, and our kitchen ab-

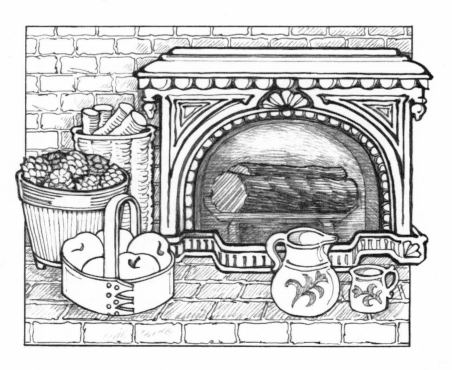

sorbs baskets well. We've hung them on brads (headless nails) so we can easily remove them from the wall, use them for serving and after rinsing them clean, return them to the walls to add decoration and texture to the room.

Wooden spoons delight me the same way baskets do. They're inexpensive, have clean, simple shapes, are extremely useful, and, grouped together in an ironware crock, are most pleasing to the eye. Many of our wooden spoons have been hand-carved and were purchased on our travels around different parts of the world. Some of these shapes go back a long way in time. A simple wooden spoon satisfies my senses far more than any metal cooking spoon can.

There are two pieces of functional sculpture that have landed in our kitchen—one is a purely decorative French brass duck press, and the other is a large brass-and-wood market scale from Lyon, France. These beautiful objects remind us of happy days together in France. The scale sits on a small Greek *taverna* table in front of the window, weighted down with apples, oranges, lemons and limes. The duck press sits on the bar sink and adds a touch of class and sentiment to our urban kitchen.

We've also collected brass and copper utensils, cooking pans and dishes, and have them hung on the walls of our kitchen when they're not in use. Kitchens tend to have irregular wall spaces because of the cabinets, so I rarely use wallpaper there. I prefer using the space to display attractive objects.

So much time is spent organizing, preparing and cleaning up after meals that having to go to another more attractive place to sit down and eat often doesn't make sense. By making your kitchen sensuous, you don't have to go too far. On many occasions the kitchen or an area nearby is the ideal place to dine in an intimate, warm atmosphere.

Each kitchen will have its own structural limitations, but ideally you should try to have an eating area near a window. I'm not suggesting expensive renovations, but a fresh look at your kitchen

to see what can be done to make it work better for you, to make it more attractive and to make it a place where you can really live.

If you have a big kitchen, make it serve as a gathering place; bring in a sofa, as some friends of ours did in their large, sunny kitchen. Other friends added a greenhouse at one end. A cook doesn't always want help as much as encouragement and company. Besides, you can read, make notes or write a letter while the kettle boils.

Man has always decorated those objects related to the eating ritual. There is only one reason for this—to make the process of meal preparation and presentation more satisfying. No matter what your traditions or tastes, there is a real opportunity for self-expression and enjoyment in the selection and use of the containers in which you serve food and drink.

There has been a great change in the availability of oven-to-table cookware and attractive plates that can withstand the rigors of the dishwasher. This equipment allows us to be elegant every day in the way we serve our meals, and they save us half the clean-up time. Whenever possible, bake and broil in the same containers you serve in; use plates and utensils, except on rare occasions, that can go into the dishwasher; and take stock of your equipment to see if the way it looks and functions is pleasurable and efficient.

Variety can elevate ordinary routines into special moments. Don't be fooled into buying a complete serving set of fifty-odd pieces in the same china pattern. Course after course, meal after meal with the same pattern can become tiresome. You're not operating a restaurant. Buy one covered tureen or one Spatterware bowl or a set of six or eight plates.

We've turned our dining room into a family library, and so when we entertain I use individually set tables in our large, long entrance hall, and I rarely have more than eight matching plates.

Don't ignore the loveliness and simplicity of pure white plates: white can be a good background for beautifully garnished food.

Ideally it is best to have an assortment of plates and dishes in varying styles so you can choose the one that best suits the dish you are serving. A peasanty quiche may be most appetizing if served on a pottery plate, whereas Irish smoked salmon seems to need fine bone china. Glass plates can be used with success for almost everything. If you have some rare antique pieces you don't want to serve food on but would like to have admired, place them on the table *under* the see-through glass plates.

Good old Pyrex can look effective, too. You can make eggplant casserole in a Pyrex dish, put it into a basket and serve it at the table, garnished with lots of watercress. Pyrex also has some simple glass bowls you can use for salads and fruit salads as well as for soufflés and casseroles.

Wooden bowls are ideal for raw foods. Serve salads as a main course in individual ones.

Inexpensive baskets in various shapes and sizes are useful. I use flat, square-shaped baskets for chicken salad: First I place a bed of various lettuces on the woven basket, covering all but the edges. The chicken salad is then placed over the lettuce. Hot water cleans these baskets in a jiffy and they drain dry in the dishwasher or in a drainboard. These same flat baskets are excellent for serving hors d'oeuvres. A napkin or doily placed in the basket can spruce up a ham-and-cheese sandwich on rye eaten in the bedroom on an evening devoted to reading. An unusual presentation awakens your senses.

Begin your planning by taking inventory of what-cooking gear you already own. By examining in detail what you have, you can reevaluate what is currently useful. Just as we periodically have to weed old clothes out of our clothes closet, we need to do the same with cookware. One's cooking and eating patterns change over time, and there is no need to keep the clunky old doughnut maker or the waffle iron if doughnuts or waffles are no longer part of your diet.

Evaluate what kind of cook you are now, and what sort of eating patterns you have. You can set up a simple system that will work

uniquely for you if you are willing to part with things that don't really function well for you any more. Think in terms of a fresh, attractive new wardrobe of cooking gear. Keep the equivalent of your pretty ten-year-old blouse or a favorite old tie you are drawn to—something you still use and like. What's left that can travel on?

Personally I have passed through my gadget phase and I'm back to basics. I need a few really fine knives, a nest of frying pans, a nest of pots, a few baking dishes, a large roasting pan, a wok, a nest of mixing bowls, some oven-to-table covered dishes, a collection of spoons, forks and openers, and I have the essentials. I'm not Julia Child and I know it. A great deal of my delight in our kitchen is having my things well organized, handy and attractive—because when I cook, the implements, the shapes, the finish and color are all part of the ritual, and if they are appealing as well, they double my pleasure in the process.

Enamel pots and frying pans are very satisfactory, and easy to care for. They are attractive enough to bring to the table. I collect them in white, a few at a time. I segregate all my white enamel equipment in one cabinet, because enamel chips if it gets banged around. You may have another preference. If you are an accomplished cook, you know best what your needs are, so perfect your system and eliminate all the outdated stuff.

Good eating is a philosophy. I know a French lady who muses, "I am the keeper of my sacred body. I guard carefully everything I put in my mouth." She eats entirely by the seasons.

Certain foods should be eaten at certain times of the year. Nothing is more disappointing than a tasteless plastic tomato in December. The best way to select fresh ingredients at the best price with the most flavor is to follow the seasons. In the early spring, asparagus comes on the market, and by June and July there are melons and berries. Corn in July. We often go to a local restaurant that has

tomatoes and basil on the menu all summer, yet only serves this dish when the tomatoes are perfect.

Shop for the best. You can make a first-rate meal with everyday ingredients if they are ripe and well selected. Vegetables that have been covered with plastic wrap in the supermarket never have the flavor of things purchased at an open-air stall. Touching and smelling the vegetables and fruit is part of the fun of shopping. One perfect tomato, one sweet white onion and a sprig of fresh basil can be the start of a memorable salad for two. When the ingredients are superb, there is little more required of us—a dash of mustard, a few drops of fine olive oil and ground pepper. Voilà!

There is one satisfying way to live well and pay less: consume less. I think there's a trend in America to buy too much, cook too much, eat too much and read too many cookbooks. This excess costs money, takes time, makes waste and clutter. Depending on availability, it is always best to buy a few seasonal items and serve them in a loving way. The best from the market, the catch of the day, is always good and you don't need to thumb through six cookbooks to discover how to prepare it. As a little girl, I remember

my mother always had a meal of corn on the cob, tomatoes and watermelon in the summer when all three were in season: the three were also in perfect harmony. I'm proud to say I grew these natural wonders in my own garden when I was seven. All these years—and thousands of meals later—I remember the corn, tomatoes and watermelon!

When you serve fresh asparagus or creamy, perfect Brie with French bread hot from the oven, or a ripe melon, you don't have to apologize for the simplicity. Nature is on your side.

In the deep of winter, when your garden is hidden under snow, delight in the Oriental fruit and vegetable stalls (mostly Korean) popping up all over, where you can buy freshly squeezed orange juice and natural apple cider and the makings of a summer salad. As I travel around the United States I've seen and applauded the trend in supermarkets of having salad bars, where everything is fresh.

Following the seasons with the best available produce and ingredients makes for ideal menus, and they are usually disarmingly simple. The panache is in the presentation. To make something very simple, memorable, it must look exquisite—a perfect ripe pear served on a hand-painted porcelain plate, for instance.

During September through May I plan hot menus, and June through August mostly cold ones, with the exception of grilled food cooked outdoors and hot corn on the cob.

The same principle applies to shopping for fresh produce and meal planning as to putting your wardrobe together. Never buy out of desperation for a special occasion; gather your clothes—your food—as you find things that suit you, fit and are in season.

When planning your menu, visualize how the food will look on the plate. Color and textural contrasts are as important as flavor variations, but when you are cooking for yourself and your family, the simple, unpretentious dishes will be most appreciated. I almost always serve a green vegetable. If you don't serve tomatoes, beets or

carrots, a cherry tomato, a strawberry or a garnish of a contrasting color such as a black olive or a lemon wedge adds interest to the look of the plate.

I will never forget going to a friend's home for dinner many years ago. We were served creamed chicken, mashed potatoes and canned creamed corn. This colorless menu was unrelieved by being served on a beige plate! A sprig of parsley, even some cranberry jelly, would have whet my appetite. It takes a great deal to make me lose it, but that night even my imagination failed me. Dinner was so dull. I couldn't taste anything at all.

A variety of taste treats is the spice of life. We all can become deadened to taste if we don't have surprise flavors in our everyday food to add some zip. After you've read some cookbooks and learned the basic principles of cooking, there should be a certain amount of serendipity.

Experiment with your basic menus. Add ginger and blanched scallions and Greek olives to your chicken one night; the next, nutmeg, bacon and sour cream to your spinach. Then add a touch of soy sauce to whatever you have in the wok.

When you next make vichyssoise, add a chopped apple to the blender. Carrots are delicious with fresh orange or tangerine juice squeezed into the butter, plus a pinch of cinnamon and a little brown sugar. Another time have shredded raw carrots with herbs in a lemon–sour cream sauce. Plan basic menus so you have all the necessary ingredients to work with before you start to cook. Then settle into a moment of fantasy and allow your imagination to take over. Brillat-Savarin might have exaggerated when he said, "The discovery of a new dish does more for the happiness of the human race than the discovery of a star," but there is some truth here. Food discoveries often occur almost by accident, and are quite simple—like the flavor of mint lemon ice or almond lobster salad. You get the idea to garnish store-bought lemon ice with mint and discover the combination of the two flavors is heavenly, so you blend them together to make it your own. You have blanched

almonds left over from a party; cut them up fine and sprinkle them over lobster and avocado salad, and you have a new taste treat.

But there is far more to the eating ritual than good food. The body responds to the subtle nuances of the surroundings because eating is both a physiological and a psychological act.

Set the stage at every meal. Architect Philip Johnson, discussing the space of the New York restaurant he designed, The Four Seasons, said, "If you build a good room, then you can eat in it." Intimacy, calm and a sense of privacy are essential, which means that where we eat should be places of refuge. It's wise to avoid TV, telephones and other harsh noises while eating, because such things cause a general stress reaction, and this kind of confusion prevents one from really tasting the various flavors and also from digesting the food properly.

The ambiance and the place where you actually set your table or trays or organize your picnic is an important part of the ritual of eating, and should be carefully considered even before you plan your menu or begin to prepare your meal. M.F.K. Fisher loved to follow the sunlight wherever she lived, and to eat wherever the sun was. Light is a real tonic. One of the ideal places to eat is outdoors —al fresco—but when this isn't practical, at least be sure to eat where there is as much natural light as possible. In the evenings, use candles or dine by firelight.

In summer I enjoy a table set in soft pastel colors that blend with the sky and flowers. In fall, when there is a crispness in the air and the leaves turn crimson, I prefer rich yellows, oranges and soft greens. Colors have seasonal moods, and opening up to the changes broadens your range of sensuous experiences.

The more you vary the way you stage a meal, the more pleasure you will have in the daily rituals of eating.

Robert Caro, in his book *The Years of Lyndon Johnson—The Path to Power*, tells of the dignified misery of Lyndon Johnson's mother's early years of near poverty and loneliness in the Texas hill country. She tried hard to maintain the standards experienced in more afflu-

ent Texas regions, refusing to use oilcloth on her dining-room table, as was customary in comparable homes, for instance. Despite the extra burden of washing and ironing, she used fabric table-cloths. Caro writes: "She made a ritual out of little things, like serving tea in very thin cups."

Toss a variety of coverings onto your dining table, maybe a cloth of French provincial cotton, with napkins in different colors—lemon yellow, lime green, cantaloupe and raspberry. Try using a set of plates you've never used before except "for company."

If you don't have fresh-cut flowers, make a grouping of African violets surrounded with lemons and limes. A bunch of fresh parsley with a ribbon tied around the vase can be a refreshingly casual centerpiece for the kitchen table, and attractively arranged vegetables and fruit can look pretty, too.

I was recently in a store, buying some turquoise-and-white polka-dot cotton napkins. The man at the checkout counter told me, "I can't use colored napkins. I've just made a black-and-white dining table and I can only use black-and-white napkins." "Oh well, at least you can get some color with flowers," I said. His reply seemed grim to me. "No, I can only use white tulips and they're out of season now." What a loss of opportunity! I wondered if he saves *living* for the white tulip season.

As always with rituals, you can set the stage with little things: a dish under a demitasse cup and saucer; a freshly baked orange tart on a see-through crystal plate; a blue-and-white pitcher filled with jasmine or daisies.

When I go into our kitchen to cook a meal, I always put on a pretty apron. The reason for the apron is largely psychological—it makes me feel like a chef.

Stemmed glasses turn blueberries or jellied madrilene into a celebration. Oversized (serving size) flatware is elegant, as are big white cotton napkins.

Serving plates are pure decoration, on which to feast the eyes

before the food arrives. Make it a porcelain feast. Select tablecloth and napkins to complement the food. Create magic at your next meal.

Simple, fresh, unpretentious home cooking is what most of us strive to accomplish in our kitchens. Few of us are professional cooks, artists who can attempt the great style. But, like professionals, we can pay attention to details.

The late Fernand Point, the celebrated chef of De La Pyramide in Vienne near Lyon, France, has a concept about dining which we can borrow: "the perfect harmony of all the senses." He always tried to please both the palate and taste buds, the eyes, ears, nostrils and the sense of touch.

Before you taste food, you see it and smell it—the eyes and the nose suggest the taste to come, usually accurately. The presentation is telling, transforming a simple dish into something mouthwatering, sublime.

Because taste is such an individual thing, there are as many ways to garnish and present food as there are recipes for cooking. The best way to think about your food presentation is that it should please your own senses. Take risks and be willing to experiment until your eyes are satisfied.

Think ahead, and when you plan the menu also plan the garnish. It should be a finishing touch, and fresh. We've all been served wilted watercress and a shriveled-up lemon slice that had been put on our plates hours before we arrived to dine. It makes one wonder how fresh the food is, and it shows lack of care. The eyes of the cook should dance over the dishes to inspect them the way an artist examines his canvas before pronouncing it finished.

With practice it will become second nature to arrange dishes in an artistic way. First, basics: When placing food on a plate or serving platter, allow the entire border or rim—at least two to four inches—to remain empty. Don't overcrowd. The food is the focal point. Don't serve asparagus on pottery asparagus plates, because it

looks artificial; it's far better to serve fresh asparagus on clear crystal or pure white china. If you do have asparagus plates, use them for an endive and Roquefort salad.

A clear consommé is a rather dull color, but it can look attractive if it is served in a prettily decorated porcelain cup and saucer. The secret is to always have plenty of marvellous "ingredients" at hand to use in your presentations—Chinese lacquer bowls, Japanese enameled serving trays, wonderfully designed plates—so that there is always an element of creativity apparent throughout the entire meal. As a writer collects experiences, a cook collects exquisite "ingredients" that will lend a magic to the presentation as well as to the cooking.

Garnishes can be a part of the recipe—meant to be eaten. For example, arrange sliced veal on a bed of braised spinach, with thin slices of lemon tucked in between the overlapping slices. Scatter finely chopped parsley across the center to give a pleasing contrast of color and texture, and display the dish on a huge pottery platter.

Serve a roast chicken circled with watercress on which you've arranged cut-up chunks of oranges and apples.

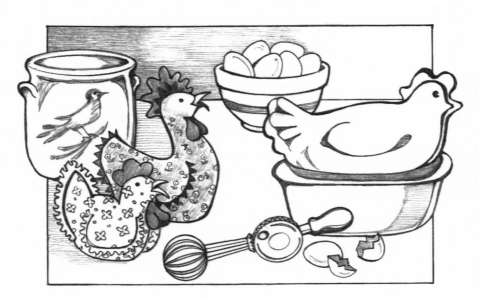

Fresh fruit, vegetables, even flower petals, are appropriate garnishes. Please yourself and trust your eye, taste buds and instinct.

If you feel your presentation needs some high color contrast—black, not red—use whole baby Greek olives. Unexpected combinations perk people up: pale pink geranium petals next to black Greek olives look exquisite. An element of surprise is always refreshing. Imagine the tastes, and try to have cool, soothing contrasts to hot spicy things—cantaloupe with curry, or room-temperature braised apple with garlicky roast leg of lamb. The Chinese understand the theory of Yin and Yang and we can borrow from their great cooking tradition.

Vincent van Gogh said that he and his fellow artists painted things not as they were but as they felt them. John Russell, in his book *The Meaning of Modern Art,* suggests Van Gogh was inviting us to enjoy the same freedom. The Impressionists have profoundly influenced my spirit. John Russell's remarks about the Impressionists have meaning in our daily lives: "Impressionism was the apotheosis of pleasure in sheer looking . . . they made us think better of life and better of ourselves."

If you're serving a plain lemon cake, place it on a green majolica leaf-shaped dish or on a Wedgwood leaf dish and slice paper-thin lemon as a garnish. A homemade pesto sauce deserves a rustic pottery plate. Serve salt and pepper in lusterware, and use tiny glass spoons.

White is the perfect setting for richly colored foods—spinach, tomatoes, carrots, asparagus; gleaming white allows food to sparkle. Rice on a white plate is lost. Heighten contrasts by putting a little color next to the rice. Try a lettuce leaf under it, or serve inside a scooped-out tomato. Put roast corn on the cob in a basket or platter on a generous bed of watercress.

Two moss-laden terra-cotta pots of geraniums resting on a nearby windowsill with the light flowing through the transparent leaves is a nonedible appetite inducer, so pay attention to what

surrounds your presentation. For example, if you're having water-melon for dessert, slice it in half, then slice one-half into two irregular-size pieces. Place the two quartered slices at angles in an artistic way and place this still life within view of where you eat. At the end of your meal—watermelon. Or fill a basket with strawber-ries, cherries and green grapes and place it on a table or a counter, away from where you're eating—then serve it for dessert.

Caring about how food is presented becomes a habit, and a lovely one.

The breakfast table is home base and gives each new day a fresh start. We are told that breakfast is the most important meal. Our stomachs are empty—we have a day ahead of us—and we need energy. A beautiful breakfast starts the day off right. Go out of your way to try to make it an especially attractive meal.

I cook breakfast during the week, and we eat *en famille* at our farm table in the kitchen—we use hand-painted Mustière pottery from France some days; other times, colorful Italian pottery plates that are chipped and cracked with wear, but dearly loved. We have a small collection of Limoges cups and saucers—some bought in Chantilly, where the Limoges is painted. We've gathered quite a variety of pottery, glass pitchers, plates, bowls, and cups and sau-cers on our travels, so there are lots of possible choices, depending on the season and mood. We serve breakfast on these one-of-a-kind plates.

Setting a pretty breakfast table sends out good signals—a classic example of action speaking louder than words. There is at least a moment to pause and be together before we all have to get moving to go to school and office.

An article entitled "Hope, That Sustainer of Man," in the medi-cal report *Executive Health* began: "Don't hurry, don't worry, smell the flowers along the way." Breakfast is a good time to enjoy being

alive, to feel the magic of a new day. Even if breakfast is simply coffee and juice, it can be elegantly served and special.

There is an inn in the South of France, Moulin de Mougins, where we have gone for rest and beauty. Breakfast is served in the garden on tables covered with fresh pink tablecloths, and we are given huge pink cotton napkins even though all we are having is coffee and juice. But the coffee is served in enormous bone china cups and saucers, and the fresh orange juice is squeezed into slender, sparkling cut-crystal glasses. I leave the garden satisfied, and realize that the soothing and restorative breakfast ritual launches me happily into the start of a new day.

I know an attractive lady in her late fifties whose weight hasn't changed since she stopped growing as a teenager. My curiosity led me to ask what her secret was. "Alexandra, it is no secret. It is so easy. I never eat standing up." No grabbing snacks. No raiding the refrigerator. No food at cocktail parties. The other part of her regime: Never skip a meal.

Lunch is an important ritual. Whether you set up a tray and go alone to a quiet place or lunch with friends or family, it is an opportunity to nourish the mind and body. Except when we're on holiday, or on weekends when we have more time, our lunch ritual is fairly simple. The essential discipline is to break for lunch—*have* lunch—a complete respite from work and busy activities. Also, I make it a rule not to eat lunch when I'm nervous or in a tense atmosphere; it's not healthy, and you'll tend to eat twice as much, and too fast.

I think skipping lunch is a mistake. Lunch is one of the three eating rituals designed to calm us down, give us pleasure and allow us time to take a breath and gather some perspective on ourselves and the world. Twenty minutes after a light lunch our spirit is improved and we're ready to attack life again.

If you have a sandwich lunch, don't eat it at your desk, where the phone can interrupt you. In sight, on duty. Be off duty for a

brief time. Find a pocket-size park or a tree on the terrace, but do go to a special place for lunch no matter how modest your fare is. When we deprive ourselves of this necessary tension-breaking ritual too often, our health will pay too big a price. A cup of vegetable soup with less than a hundred calories can do wonders to your disposition if it is served in an appealing way, and if you take time to enjoy it.

An omelet is so easy to make and always seems special. One secret to a wonderfully fluffy omelet is to beat the egg yolks separately from the whites and lightly fold them together. A Teflon pan cooks omelets wonderfully. Have a friend for lunch and serve omelets, because they don't take much preparation time—you can grate cheese and chop herbs the night before.

We are all eating more lightly and no longer feel the urge to sit down to a rich, heavy evening meal. A piece of grilled fish or chicken attractively garnished and served on a pretty plate accompanied by a salad is not a chore to prepare and is refreshingly light and nourishing. The secret to having happy, leisurely dinners at home is to keep it simple. Cheese and fruit after dinner requires no preparation time; salads are easy and can have infinite variety. Some evenings, when I'm in the mood to cook, I make a double batch of eggplant parmigiana and freeze a portion to use later.

Sometimes plan for a change of pace: the ritual of dining out while staying home. None of us can keep up the momentum of preparing dinner night after night without a break. Plan "cook's night out," and arrange to pick up prepared food in your neighborhood. If there isn't a gourmet shop nearby, perhaps there is a neighbor who cooks for profit. You may even discover a teenager who can cook and wants to earn a little money.

Or once a week, even in winter, plan a cold dinner. It can be refreshing. Yogurt, salad and a variety of cheeses can make an excellent evening meal. A few juicy tomatoes and leftover cold lamb with rye bread turns something simple into a memorable taste treat.

Making a soufflé is a unique eating ritual. I don't serve soufflé

when I have friends in because I don't want to be anxious about whether it will rise to perfection—we make soufflés collectively as a family ritual and we've become quite accomplished at it. We began making cheese soufflés when the girls were little. We start by polishing the copper mixing bowls and getting out the egg whisks. The process enhances the fun. Each of us feels clever every time we sit down to a supper of soufflé and salad.

Having friends in for soup and salad is a wonderful spur-of-the-moment ritual. When the mood strikes you, make two or three different soups and invite friends over informally. With some good French or Italian bread, a tossed green salad and a cheese tray, you have the perfect ingredients for a relaxed buffet supper. Make your soup one week and freeze it—ask your friends over the next week. Soups, like casseroles, freeze well.

Dressing for dinner helps make dining a ritual. Don't cheat yourself; dinner at home alone is just as important as dinner out or with guests. Dress for it.

I drank at every vine.
The last was like the first.
I came upon no wine
So wonderful as thirst.

EDNA ST. VINCENT MILLAY,
"Feast"

What we drink can enhance the pleasures of a good meal. Whether we have mineral water, wine or orange juice in our glasses, it is part of the eating ritual to drink and to make toasts. It would be impossible to think of eating without thoughts of drink.

Twenty-five years ago I was in Southeast India with my aunt, who was an international social worker. She took her three oldest

nieces on a trip around the world. When we were seated at the dining table for luncheon, we were presented with lamb curry. One bite and we thought, a drink! Our host immediately offered us beer. Our aunt was stunned at the thought of teenagers drinking beer, and she declined. Our host, a doctor who had a great gift of balance, soothed her as he poured the beer into our glasses. "Moderation in everything, Betty. Even virtue." She joined us and admitted that beer and curry go beautifully together.

If a pitcher of water is on the table, it will be used.

People often have strong feelings about the glasses in which they are served drinks—the right glass can enhance pleasure.

Some people prefer heavy cut-crystal glasses, others like thin, light ones. I prefer a variety, so I can match the glass to the mood and beverage. When selecting glasses, please yourself. Don't worry what kind it is—if you buy some tulip wineglasses you can put ginger ale in them, or champagne. Buy a pleasing shape. Feel the lip of the glass with your fingers; it should be smooth and not thick. If a glass feels good in your hand, looks attractive and you can afford it—which implies you won't weep if it breaks—buy it. The Pottery Barn in New York is an excellent source of practical everyday glasses at reasonable prices.

A pitcher full of iced tea kept in the refrigerator is handy and refreshing throughout the summer. Offering a cool drink is a gracious act.

*There are few hours in life more agreeable
than the hour dedicated to the ceremony
known as afternoon tea.*

HENRY JAMES
The Portrait of a Lady

The tea ceremony can be a ritual of giving and receiving. It requires tranquillity and patience, as well as the grace to absorb the subtle nuances of a cultured life lived well. Sadly, all too often, most of us are too rushed and too pressured; we don't have time, and we don't take time, for tea.

The Zen monks returned to Japan from China in the twelfth century, bringing with them the powdered green tea they used as a mild stimulant to enhance their meditations. Today the tea ceremony is an aesthetic ideal, with attention paid to tea utensils, a flower arrangement, paintings and food. The mere fact that you can boil water, add tea leaves, and create a powerful experience, forces us to pause. The purpose of the tea ceremony is to entertain, to share, to convert life gently into a work of art.

The tea ritual is one of purification. Inviting someone to tea implies caring.

GRACE NOTES

• Make the inside of your refrigerator a feast for the eye, with see-through containers and bowls full of fruit and vegetables. Flowers last longer when refrigerated. Try keeping a small bunch of flowers in the refrigerator. Surprise pleasures delight the most.

• Put breakfast supplies in a cabinet above or near the kitchen table, so you can set it without moving around a lot. Setting a pretty table is a sustaining ritual, and if you have everything handy, you can vary it each morning.

• Rehang the kitchen door if necessary, for more space and a better view.

• Begin a copper pot and pan collection; hang them on the wall for decoration when they're not in use.

• Put strawberries in a bowl and leave two, with stems on, on the table next to the bowl. Take a flowering sprig and place it off-center in the bowl.

• Serve tea from a porcelain teapot that has been hand-decorated in colors that are attractive with your cups and saucers. Keep it ready on a tray for spontaneous tea rituals.

• Serve hot perfumed freshen-up towels after you've served artichokes.

• Make lobster, avocado and wild rice salad for a picnic.

• Serve cold strawberry soup in a silver bowl.

• Use hand towels as generous lap napkins.

• Buy all-purpose glasses that can be used for cold drinks, wine, breakfast juice, and cold soups and sherbert.

• Buy some new dishtowels to add cheer in the kitchen.

• Treat yourself to a small tin of truffles and dine on a truffle salad.

• Have all your knives professionally sharpened twice a year. Mark your calendar.

• Hang a string of garlic on the wall and use it.

• Put eggs in an old wire basket.

• Make a ritual of buying or baking fresh bread and leave a whole loaf out in view, on a wooden cutting board. Food set out attractively whets your appetite.

• Place fresh flowers in water in an extra sink or in a bucket and just leave them there until they need to be placed around the house.

• Serve salad on a glass plate. Have greens around the edge to hide the glass. Place on a basket with three strawberries and crusty French bread.

• Store candles in the refrigerator; they'll burn longer.

• Buy a citrus fruit essence extractor and sprinkle needle-like slivers of lemon, lime or orange peel over soup, fresh fruit, roasted chicken or lemon parfait.

• After baking apple pie, put on rack to cool and have a pile of apples on the counter next to it.

• Store lemons, limes and oranges in a see-through glass bowl in the refrigerator. Put out on the counter when you are cooking. Pretty and useful.

• Keep butter in a pottery crock.

- Serve green grapes with Roquefort cheese on hard pumpernickel rolls.
- Decant olive oil and wine vinegar.

- Use decorative molds for mousses and aspics. They're attractive to hang on the walls of your kitchen, and you can use them for something that is relatively simple to make but provides a nicely festive air.
- Use an old Welsh dresser, English baker's cabinet or French armoire in the kitchen to store dishes and silverware.
- Keep hand-operated can openers and bottle openers in several different drawers.
- Build a 42" to 44" tall counter for times when you like to stand and work. High stools make it fun for eating, too.
- Grill swordfish with mint butter.
- Serve lobster and smoked salmon on shiny white oversized plates 12" in diameter.
- Add red radicchio lettuce to a green salad and cut up goat cheese to sprinkle over the top.
- Grate fresh Parmesan cheese on a spinach salad.
- Marinate a chicken cut in quarters in freshly squeezed orange juice and fresh sliced ginger root, then bake slowly for two hours at 250°.
- Make a July ritual of picking blueberries and strawberries, and then go home and make blueberry muffins and strawberry short-cake.
- In autumn go to see the fall foliage and pick apples (you pay by the bushel). Make cider, applesauce and apple pie. Your house will smell warm and sweet and cinnamony.
- On a cold afternoon, bake chocolate chip cookies and leave them out on cookie racks. Nothing says "home" faster than this smell. Or you can give some of the cookies away to an elderly neighbor or a neighbor's children.
- The next time you make toast, butter it, sprinkle with cinnamon sugar and place in the toaster oven for a few more seconds.

• Make a ritual of weekend breakfast and serve scrambled eggs, croissants and crisp bacon. A treat! Add a selection of marmalades and jams.

• Add a pinch of cinnamon and ground cloves to your ground coffee. Brew, and drink out of your favorite mug.

• Keep a food inspiration notebook in the kitchen. Cover with pretty paper and use for menu and recipe clippings, and to jot down ideas. This way everything will be in one place and you will have inspiration handy for new ideas when you plan your meals.

• Turn a plate of fresh fruit into a still life and place it in your bedroom to feast the eye and satisfy a late-night craving.

• Keep a pepper mill on the table. Our daughter Alexandra's nickname is "Pepper," because she can never get enough fresh ground pepper.

• Use place cards at your next dinner party. People will sit where you have put them, and it makes the evening more festive. It's also practical to know the names of your dinner partners. Attach a humorous fortune cookie to the flip side of place cards, just for fun.

• Save perfume bottles to use as individual bud vases. Select a variety of shapes and sizes and different blossoms and buds.

• Have a tiny present for each dinner guest. A little black book for a man, a pink powder puff for a lady. Everyone loves a present.

• Buy an old farm table for your kitchen. This might be one of the best investments you've ever made, because of the thousands of hours of pleasure it will bring. Kitchen tables are where children do homework and where families gather for meals and in between.

• Treat yourself to new colorful pot holders; make it a seasonal purchase—they get a lot of use and can look tired.

• Collect a variety of bright paper napkins. Paper hand towels are great to use as napkins, too. Stripes, polka dots, colorful solids and flower prints spice up a meal and give zest to a table setting. Variety doesn't cost a penny more.

• Spread a pretty tablecloth over your coffee table and serve tea to a friend in front of the fire.

• Use napkin rings, ribbons, dried flowers to dress up your every-day table.

• Put a quilt on top of a table outside and have lunch on a crisp sunny fall day.

• Buy charming aprons and "dress up" chores that give you plea-sure. Wearing an apron that adds color and cheer puts a smile on your face.

• Serve finger bowls after eating finger food—anything from corn on the cob to lobster. Warm, lemon-flavored water with a rose petal floating in it is pretty and it's so easy to add this small luxury.

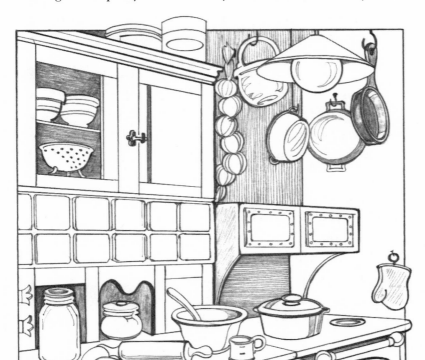

• Brush up on constellations and then go for a star-gazing walk when the moon is full. Dine by the window.

• Call a busy friend and make a date to meet for an early breakfast visit, to catch up.

• Make Sunday night special—create a ritual that punctuates the end of one week and the beginning of the next.

• Sprinkle Parmesan cheese on popcorn. A healthy, low-calorie snack—I picked up the idea from Jane Brody.

• A wonderful substitute for crackers is to slice bagels paper thin and roast with butter and herbs; eat crisp with salads and cheese.

• Retrieve a set of those pretty plates you have hidden away in a kitchen cabinet, and hang them on the wall for all to see. A good hardware store will have plate holders in several sizes, designed for hanging.

• Add to your candle supply. Colored candles to coordinate with napkins and plates help to make a supper of leftovers a special experience. Keep a good selection on hand; store them in a clear plastic box (the kind made for storing shoes). A collection of candles forces us to be more creative with our table settings.

• Stencil your kitchen cabinets. Paint stores sell stencil kits. It's

easy, creative and fun, and the design will add charm to your kitchen.

• Spruce up the back splash in your kitchen with some hand-painted French tiles.

• Serve chicken salad in scooped-out vegetables, such as acorn squash, bringing more of your garden to the luncheon table. Use the pulp for a delicious squash soup.

• Begin a "New Attitude" diet today. Make a list of ten reasons why you want to lose weight; repeat them each morning when you awake and whenever resolve weakens. Indulge yourself once a week with a special low-calorie treat, like a big bowl of raspberries.

YOUR OWN GRACE NOTES

CHAPTER 4

THE BEDROOM: MAINTAINING A
BALANCE BETWEEN
BUSYNESS AND SOLITUDE

*Y*our private time is one of the most sacred times in your life. For most of us today, privacy is not automatic, it's a precious gem that must be guarded. It is important to establish rituals to protect and enhance your privacy and your leisure. In this chapter, we'll talk about daily private rituals that I believe are vital to one's sense of well-being. You can turn your bedroom into a whole world—there, just waiting for you to open the door.

Each of us lives quite differently, and we have our own unique patterns, rituals and schedules. But I've come to realize we all share the need to get away from everything and everybody and to be alone —regularly.

Philosophers have taught us that, in order to live wisely, we must learn to balance and integrate the time we spend in society and the time we spend in quiet and calm, and ultimately in solitude. The ideal balance between our outward and our inner lives, it seems to me, should be approximately fifty-fifty. Half our time is spent doing, striving, struggling, coping, making an effort to accomplish set goals, meeting deadlines, being outgoing—being available—

"to-ing and fro-ing," as Buckminster Fuller would say, and the other half, ideally, spent in a calmer, more quiet state—peaceful, in privacy, at leisure. The only way to accomplish this is to have set times, rituals, when you are available only to yourself, to do precisely what *you* wish.

Montaigne talked about being able to take things in your stride and live *to the point.* To me, living to the point means extending moments, making moments add up to ten, living completely in the present enriched and nourished by sustaining rituals. If we're not able to keep this delicate balance between our private and our social rituals, we become fragmented and less ready for new and creative ideas. Life becomes more superficial; we get in a rut. George Bernard Shaw said that to be in hell is to drift: to be in heaven is to steer.

Rituals of quiet and calm encourage us to enjoy our own good company: they help us to replenish our own wells, which get depleted in the busyness and rush of everyday demands and pressures. An expression often used in our family is, "Ah, a moment's peace!" Bishop John Coburn of Massachusetts says he takes time to be alone each morning so "I won't be worn thin." A time set apart each day, when you can unwind, be in touch with and restore yourself, is as necessary as a nutritious diet and enough sleep. But, in addition to this, we all need the daily ritual of solitude.

In solitude we give passionate attention to our lives,
to our memories, to the details around us.

VIRGINIA WOOLF
A Room of One's Own

Solitude should be a daily ritual because it helps to keep our lives well balanced. Yet many of us tend to have a love-hate relationship with it. Rollo May, in *The Courage to Create,* reminds us it is characteristic of our time for people to be afraid of solitude, yet

once you make it a daily ritual you will discover you come to embrace it, and be nourished by its benefits. My dictionary says solitude is the state of being alone: seclusion and solitude is synonymous with isolation.

The poet Rainer Maria Rilke, in *Letters to a Young Poet,* teaches us to welcome solitude, to consider it a positive experience, not something to dread. He believed solitude was a burden but also a gift, and he embraced it as a necessary condition for his poetry and his life. Solitude is the foundation for all genuine work. Many of us don't have a room of our own or a private studio to turn to. How then can we eliminate distractions and feel alone, even if we have little space and time? Recognizing this daily need opens the door to discovering ways to invent solitude rituals. It's part of self-preservation, and of really living your life, to save some space around you at key moments each day.

I think of leisure time, intimate time, solitary time as time in which to plant seeds that will grow and flower in unknown, undiscovered parts of my life. In Letter One of Rilke's book he writes, "Go into yourself . . . Dig into yourself for a deep answer." In Letter Three he states, *"Everything* is gestation and then birthing."

A friend told me recently about a course given for successful career women that teaches how to build in quality time alone each day. We all have a tendency to schedule time for work and chores and family, but not to be alone with oneself. Yet you really must give yourself equal time. One critical truth I've learned is that no one else on earth can give you your own space—you have to take it.

You need to schedule time alone for yourself, to collect your own thoughts and get in closer touch with your feelings—sorting out other people's goals from your own. Rid yourself of the priorities of others, and take time to preserve interests that are special to you. No office, no children, no spouse, no in-laws, no friends, no work. Amid the pressures of obligations and responsibilities, you must learn to be unavailable to the rest of the world each day, so that you

can be more completely available to yourself, and ultimately to others.

Fifteen minutes here and there can save you. Try getting up fifteen minutes earlier than anyone else or staying up fifteen minutes later so you can be utterly alone. Take a very long bath.

Perhaps you could take a low-key business trip—one that might not be absolutely necessary—and leave early so you can spend an extra night someplace special, in a charming country inn or a luxurious city hotel, where room service could bring your dinner, or you could dine alone in an attractive restaurant. Build in lots of extra time alone—time to spend half a day in bed catching up on your journal, or on magazines and newspaper articles, propped up with extra pillows. Visit an art exhibit. Do things that will refresh your mind and relieve tension. Take a walk to work alone, so you have time to think between family and office. If you live too far away from the office, walk a mile before you take a taxi or bus. Or drive only halfway, then park your car and walk the rest of the way. The secret is to be a professional person with *yourself,* and give yourself the same attention, thought and care you give your clients and family.

Go to a gym and work out. Have a massage and a sauna. If your hair is wash and wear, go to a hairdresser once a week just to relax. Having someone else wash your hair and blow it dry is relaxing. Or sit under a dryer with your feet up, and indulge in a book that has nothing to do with your work. Another day, hole up in a good bookstore for a while, and browse until you feel totally transported.

A writer who took the course mentioned earlier confessed she drove around until she found a secluded spot and sat there for several hours, writing and meditating. No one knew where to find her, because she changed her route each day. She needed to be totally removed from her daily world—a world full of details and unfinished business—in order to think. In bad weather she goes to a library.

You will have to invent your own ways to escape and have un-

hurried, creative, leisure time alone. Circumstances might change its timing or even its location, but the solitude ritual must become a daily discipline—a commitment to yourself. A pact. Every day can be different, and that's part of the adventure.

Wendy just had her first child and loves her new baby girl tenderly, but found it difficult at first to get used to the new schedule and the distractions of having a nurse living in (someone who liked to talk!). Baby Sara is sleeping on schedule now, and her mother has learned to plan for solitude. As soon as Sara lies down for a nap, Wendy goes into her bedroom, turns the telephone off and shuts the door. The house rule is "do not disturb" until the door is open. I had lunch with Wendy a few weeks ago, and she is working on a new novel. The time of day when she can be uninterrupted might vary, but she lets go of other things in order to be alone part of every day; it's a ritual, just as predictable as Sara's daily naps.

A writer friend being interviewed after his third book was asked, "What is the most difficult thing about your craft?" His answer was alarmingly honest. "Sitting alone in a chair long enough to put my ideas on paper!" All of us have some resistance to being alone. You might fidget at first, or call a friend, or leave your seclusion to peek at what others are up to, but give yourself time and you'll settle into a comfortable state of mind. Wait out the feeling "I could get two or three other chores done," or "What am I missing out on?" or "What's going on out there, where I'm not!"

When we are deprived of time alone, we become starved to escape to a quiet place, where the noise and distractions of other people are far away and we feel we have ample physical and psychological space around us. We learn about others when we are with them; when we are alone and silent we discover things about ourselves. And then we are able to tap our inner resources, our intuition and imagination.

Everyone I've met who allows himself time alone makes exciting discoveries, and seems happier and calmer to me than people who go, go, go, until they lose their perspective. If solitude is so richly

rewarding, why do we find it so difficult to plan for? If we don't have it, life somehow slips out of our control. Yet once we take the time to be alone, to daydream and reflect on the details of our daily lives, we are nourished and see with greater clarity what we should do to improve the balance of our lives. Reflection increases our confidence and we're less easily overwhelmed.

Learn to be unavailable and to feel comfortable about it. Being persuaded to squeeze in one last thing, or being talked into doing something you don't really want to do when you had planned a drive to a deserted piece of property where you could have a long walk alone will only tend to frustrate you. Make appointments with yourself and be unreachable until 2 P.M. or after dinner or however you've arranged your particular day. Ink in your "free" time with your own initials in your date book. The reason busy women need to be told how to have quality time alone is often because their company, both professionally and personally, is highly sought after.

When my older sister, Barbara, wrote a successful book called *Pull Yourself Together* she was bombarded with invitations from people she'd never heard of and her privacy was invaded by the phone ringing constantly; her mail became so horrendous she had to hire a secretary to help her answer it. This only further frustrated her—she had less and less time alone. Her solution was very reasonable: She edited the invitations carefully and only accepted a few; she got a telephone answering machine—and then she went away for a two-week vacation to begin a new book.

Learn how to say "no" without going into fictitious details. Just say no, you can't: you're sorry, you're busy that night. It's true— you're busy with yourself.

One of my interior designer friends and I were having a drink together, discussing our jobs and the difficulties of scheduling. Georgina said, "It's not how many jobs you take on, really, it's how good the job is! Good jobs are so much fun that you work faster and better and things run more smoothly. It's the 'stickies' that seem to take too much time. I've learned to say no to new clients

unless I'm really going to be challenged and excited about the job. The way I say 'no' is to tell the client I'm busy for the next six months; no one is willing to wait for six months. And by saying 'no' to the wrong jobs the perfect job *always* comes along. Saying 'no' actually prepares you somehow for something exciting on the horizon. I've learned to trust that. And the job that doesn't excite me might excite someone else—it might be perfect for another person."

I find that what my friend said is true—if I am dragging my heels about something, my energy and time are sapped: I'm not at my best with people and situations that don't feel a hundred percent comfortable. Saying yes to one more ho-hum job or story or book or dinner party robs you of time alone; you've given in to losing a gem. Ask yourself who is more important, you or saying "yes" to something you don't have your heart in. Learn to let your intuition guide you, and don't get distracted so you're blown off course. But if you are, learn from it and apply your new lesson to the next time.

A very successful advertising woman, mother of two teenage daughters, told me her secret. Two days a week she has lunch with herself; on the other three days, she gets up an hour early to be alone, and on weekends she spends her two hours alone Saturday and Sunday mornings before making a late breakfast for her family! She's carved out for herself nine hours of quality solitude a week— some every day. She guards this time carefully, as she feels it gives her equilibrium and the ideas she needs in her demanding, fast-paced life. her solitude rituals at home have a prop—Sosha keeps an oversized pad in front of her, a pure white page, and anything that pops into her mind she writes down. Unless she has time alone to do this, she finds she gets ideas that are lost in the clutter and rush; her circuits get overloaded, and even simple decisions seem harder to make. Time with her "stream-of-consciousness pad" helps her release all the valuable clutter. When Sosha gets in touch with her own voice, after these moments of silence, she says she emerges feeling she can lick any problem. When I have lunch alone,

I use my Filofax to note down inspirations, in much the same way Sosha uses her pad.

I have a friend whose solitude ritual is gardening. At the end of each day, he waters and pulls weeds or plants seeds and bulbs as the season dictates. This makes him feel refreshed when he goes indoors, showers and prepares for the evening.

"If I didn't have my time alone in my garden to think, I couldn't carry on. I find solutions for difficult problems, I'm able to reflect and dream and no one bothers me. All the time I'm awed by the color and scent in my garden and have a renewed enthusiasm for the way I want to live my life."

A landscape architect walks in the woods and feels the mystery and majesty of nature, and his cares evaporate.

"After an hour or two in the wilderness I feel the miracle of life, and I feel fortunate to be alive. I need time in nature, alone, and invariably I emerge with some revelation, some sense of an expanded vision and understanding."

Rituals of solitude are essential to all artists. In a studio, a place off limits to others, the artist begins to create his own reality— whether by writing a scene or painting a picture or creating a symphony. *You* are an artist too, creating living art every day. Each of us has some unique gifts and we get close to them when we are left alone to explore what they really are. I've listened to clients from all over the world telling me how they came to paint or sculpt, or play the piano or make pottery, or run a business, and all their discoveries were made in solitude. Virginia Woolf's term is "a moment of being," so that a "shock" to our state of reality can intrude —that marvelous feeling of ecstacy when you discover something new to be passionate about.

A pianist friend from Birmingham practices eight hours a day; she has a piano in a separate room where she can go and shut the door. But when she wants to be alone, she prefers to sit in the living room. When she travels on business with her husband, Karen brings along a silent keyboard so she can practice in her hotel room

without disturbing anyone. She gave a solo concert in Italy last August, and is working toward another concert next summer. Why does she play the piano? What is moving her to play better and better? The creative life is rooted in what Emerson referred to as the expression of our particular genius. It is gifts like these that seem to flower in solitude. Karen says, "I need to play to be happy. This is such a priority to me that everything else seems simple. I play for myself. If others like my music I am happy. I can share it. My music is me."

Rilke reminds us that works of art are of an infinite loveliness. I've grown to believe that by deliberately programming in precious solitude rituals every day, we can tap into countless exciting self-discoveries that feed our egos, our confidence, our lives. We need to stay balanced between self/self-knowledge and relationships with others; both things are closely interconnected and should be given equal priority.

An actress was alone in a house she rented in Massachusetts while performing in summer stock. She caught herself singing as she was unwinding between rehearsals. She realized, "Gosh, I have a voice. I can *sing.*" So, alone, uninhibited by the need for outside approval, she sang and sang and sang. Then she decided, "I can act *and* I can sing! I can take a part that requires me to sing!" That summer she started to sing in a cabaret!

"I have more options now. I sing all the time when I'm alone. Somehow I feel barriers dissolving and there is more pleasure and fun in my life. I've gotten over my fear of singing in public because if I am satisfying myself, then I can project that feeling."

Solitude, time when one is left alone, free to daydream and reflect, allows one to set one's sights higher and deeper. Discover quiet places—a garden, a reading room in a library, the corner nook in a café, a botanical garden, a chapel, the rotunda at a museum, a terrace, a hammock—places where you can go alone, to be left alone.

In his book *The Artist in His Studio,* Alexander Liberman presents a photographic record of contemporary French artists at home and in their studios. While an essential quality for any true artist is separateness, Liberman shows how people merge with the objects in their environments, showing with psychological insight how the two become one. In his introduction, Liberman states: "The more I explored, the more absorbed I became with the mystery of environment. Why should France have become the focal center of painting and sculpture at this particular time? What relationship exists between the painting and the vision of reality that daily the artist

has before his eyes? At no time have I believed that environment is a complete explanation of art. I am sure, however, that it plays an important role." He believes the creative process is man's search for truth and he looked at the studios with the painter's truth in mind.

It is in this spirit we should look at the bedroom—a wonderful, private environment.

Most of us spend an average of twelve hours a day in our bedrooms —tidying up, dressing and undressing, arranging our wardrobes, exercising, reading, reflecting, sewing, writing, puttering, sitting, talking on the telephone, listening to music, watching the weather, planning, watching television, playing with a child, loving, day-dreaming, sleeping, nursing a cold, eating meals on a tray, napping —it is possible you might spend half your life in this environment! It should be beautiful, a private sanctuary. It should suit you.

We're told we spend one-third of our lives *in bed*. It's important to concentrate on making your bedroom all you wish it to be.

I've observed, from hundreds of clients all over the country, that, increasingly, the bedroom has become a personal refuge, where people spend more and more quality time. It needs to be serene and pretty. Details are important; you want your eyes to fall on nourishing things. Your bedroom can summon up the peace of a summer's afternoon in the country.

Years ago I was asked to do the interior design work for the first floor of a house in Darien, Connecticut. When I asked if I could go upstairs, just to get a feel for the way the family really lived, I was told that upstairs was off limits, no money was going to be spent there.

"Downstairs is where we do our business and social entertaining and we want you to do the areas that will be 'seen'." This made me sad.

But unfortunately, over the years, I have found that in many homes the master bedroom has been one of the most neglected

rooms in the house, a room that has been badly misunderstood. Now we are finally realizing that we don't go there just to go to bed or to sleep; bedrooms are being taken more seriously, and planned with the same attention to detail as rooms that are on public view.

The bedroom houses our solitude, our intimate love relationships: It's a room that must ring true, that should have purity and simplicity, and details that sustain you. I believe it's worthwhile to put your energies into getting this room to feel right, first—and *then* reach out and create rooms for public view. There is so much living that can go on in this private room. The time spent in the privacy of our bedrooms is a necessary time of renewal. Your bedroom should help you regain your harmony and sense of self and purpose. We know that we need renewal; create in your bedroom an atmosphere and climate where you will experience it. This room should encourage serenity; you should emerge from it with energy, enthusiasm and a strength of spirit you can share with others. Your bedroom life can be rich, sentimental, whimsical, sensuous and luxurious, with rituals no one outside it need share.

Our youngest daughter, Brooke, has a disposition like a lark. Her bedroom and ours connect through my tiny closet. When I proposed enlarging my closet, which would require taking several feet away from her spacious room, she got tearful and explained, "This is not my room, this is my whole world." We left her world intact.

Create an atmosphere in your private place, an atmosphere with the illusive ingredients of mystery, femininity, dreams, hopes, fantasies and love. While there are recipe books on how to cook, picture books of living rooms that give you ideas about decorating, there aren't very many source guides for bedrooms.

Let your five senses guide you in setting up your bedroom—the soft feel of cotton sheets, the scent of floral potpourri, bayberry and cypress-scented candles. Have lots of fresh down pillows in various sizes and shapes, and collect pretty pillow shams. Vary your sheets and pillowcases each week. Some pillowcases have a different design on each side, which adds variety. Select a mohair or fringed

wool tartan blanket to curl up in and have a brief nap or to pull over you while you sit and read.

A portable tape player near the bed makes listening to your favorite music an effortless ritual that will lift your spirits.

One way to think of your bedroom is as a special secret place in your life, almost as though you have to travel to get there. Once you've arrived, you're alone and calm, and you can shed your cares and your clothes. Look around, imagine and describe what you would envision there. In what places have you been especially content? Where have you found great happiness? Envision a garden, a beach, a mountain top, a forest of white birch trees, a path in the woods with a brook alongside. What would be an ideal setting for you, if you knew you would spend half your life there? If you were to be sick, what atmosphere would promote a speedy recovery? Then think about how to create that atmosphere.

Sometimes looking to the past helps. I asked a client recently what she would visualize for her bedroom. She said, "A combination of sky, the ocean and my cutting garden." Mary has a blue-and-white carpet, soft blue-and-white wallpaper, chintz sprinkled with white tulips and primrose everywhere—her bed, sofa, chairs, footstool and pillows.

Conjure up images of beauty from your memory and then physically and symbolically go about bringing the elements together in the space you've set aside for your bedroom. If you like a garden atmosphere, consider grass-green rugs, floral chintz; or a blue rug and walls, with floral patterns everywhere else. Use the colors of scenes you love, and paint the same kind of portrait in your private place.

A friend of ours has learned he is only happy living in white houses, and he always paints the ceiling of his bedroom "perfect sky blue," because he enjoys being in bed and looking up: A blue ceiling reminds him of when he was four years old and was lying in a haystack on his family's ranch in Texas on a crystal-clear summer's day. "My brain and heart make the connection of my first

memories as a child, when I look up at my bedroom ceiling." Kenny lives in a white house which he modestly calls "the happiest house in America!"

One client feels happy just looking at the pastel grosgrain ribbons tied around her chair cushions, because they trigger vivid memories of when her daughter, now in college, was a four-year-old, wearing the same ribbons on her braids.

A client in Illinois cut out the smocking from one of her daughter's pink baby dresses, and made a baby pillow with the salvagable parts. "I can hold this pillow and remember Cynthia as a baby." Cynthia is now married and has twin two-year-old boys!

The mood you create in your bedroom holds great power of association; it can become a self-portrait of your past, your present

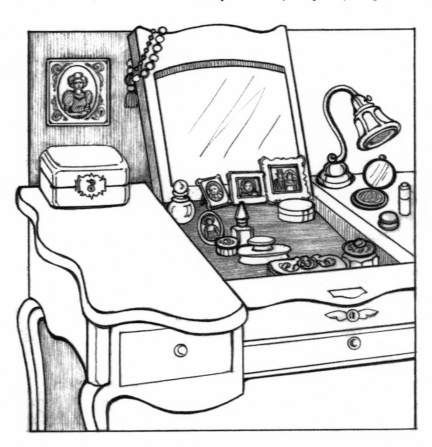

—who you are now—and it can give you a taste and vision of the personal journey that lies ahead.

A well-known actress goes on the road for long periods of time, living out of suitcases in ordinary institutionalized hotel rooms. We had lunch recently upon her return from a six-week shooting, and I asked how it had gone. The first thing she said was, "I've learned something. Never again can I go into a hotel room—no matter how big the room is—and expect to survive without some of my personal things around. Half the time the room smells of cigars and acrylic. The windows are hermetically sealed—I couldn't air things out. The scent of my potpourri went down the same vent as the smoke from the guy's cigar at the end of the hall. The stale air kept recirculating. Worse, half the hotels used brown bedspreads and orange sheets! The twelve hours I wasn't on location I had to exist in this horrible atmosphere! I could rest and study my lines, but forget sleeping—the room was too dreadful. I'd shut my eyes and see witches and ghosts."

Ms. X craved a place she could retreat to when she wasn't on the set, but an ugly room made her nervous. Although she has a lovely figure, she gained five pounds the first week she was away. She was starved for beauty, so she satisfied her hunger with food!

Her solution for the future is to bring along a suitcase of things that will give her a sense of connection—framed family pictures, some pretty pillows, a blanket cover and top sheet (you can always hide the bottom one), some pillowcases, scented candles and elegant scarfs to drape around.

Even when we're exhausted, it can be hard to unwind. The colors of your bedroom are important in helping you relax.

Another actress was driven over the edge of fatigue because her decorator selected shiny, sun-yellow walls for her bedroom. Her acting schedule meant late nights at the theater, and she was forced to catch up on her sleep in the daytime. The cheerful yellow walls

sent out signals, "Get up, get going, do something useful!" In place of the yellow, she eventually created an Oriental theme, with coral-sand colored walls that made the room peaceful, calm and *quiet*.

Over eighty percent of my clients sleep in blue rooms. Studies prove that blue is the most soothing color: that's why the navy uses blue for the interior of submarines, hospitals use blues and greens. One can unwind and be calm in a room on the cool side of the spectrum—pale pink, lilac, silver, seafoam green, pale blue and white. They are refreshing yet serene bedroom colors. Pastels are calming and meditative. Select your favorite cool tones for your bedroom, and avoid bright yellow, red and orange—colors that make one feel more active.

Set up systems that help you keep the bedroom neat, so that even when you are tired or rushed, you can keep this special place calm and unclutterred. Have a place for everything so that when you undress you are relaxed—you can automatically place your clothes in convenient spots, and then you are free to dream about your day and not have to fight to find a skirt hanger. Have ample hangers in the closet, pencils and paper next to the phone, stamps near stationery and provisions made for storing books. I keep a wicker basket next to each side of our bed and pile fresh supplies of magazines and books in them, ready to greet us.

One of the decorative storage boxes I mentioned earlier gets supplied with bedtime material—articles I've clipped, personal letters I've saved to read leisurely in bed, and some notepaper in case I want to jot off a note in reply. The bedtime box also makes a good lap desk.

Make an evening ritual of setting the stage for intimacy. Close the shutters, draperies or blinds, turn on low lights (picture lights warm the colors of your paintings, and floor lights add a glow to a dark corner). Light a scented candle, an incense stick, or a ring scented with oil, and imagine yourself in the South of France. Turn down the bed.

One of the greatest joys of being a woman is to be able to pamper

a man; introduce little luxuries and pleasures to the man in your life.

The preparation of the bedroom for evening should have a special ritualistic significance. After I've turned down the bed, I lay out my nightgown and robe—this is a very nostalgic gesture, as it takes me back to when I was a child and my mother did it for me.

Putting on fresh, loose clothing, and approaching the bed at the end of a long exhausting day is one of life's delightful moments. The anticipation of an uninterrupted peace is special. Your bedtime ritual is terribly important and should not be rushed.

Set the stage for bedtime by having a few practical luxuries at hand. An attractive, accurate alarm clock is a necessity. The clock is often the first thing we see when we awaken, and the sound of the alarm, the rhythm of the movement, can be a comfort or an irritation. Be sure your clock is reliable and provides you with a comforting, soothing element.

When I am quiet and peaceful I am far more receptive to beauty, and my senses awaken fully. It's nice to have pictures of loved ones next to your bed, and also a flower in a bud vase. Virginia Woolf admits to looking at a single flower and in a moment discovering and understanding the reality that the whole world is art. Contemplated just before falling asleep, a flower can have the power of an entire garden. It's soothing to have a special flower to study and appreciate. I try to select one for my bedroom that has a strong scent—paper-white narcissus, tuberose, gardenia, jasmine or hyacinth, but many people can't sleep with a strongly scented flower next to their beds and prefer a more delicately perfumed one. The point is to have near you something alive, something beautiful, and something that holds a special meaning.

Scents have a unique influence over us because we form associations with them. The smell of lilac will always bring back my childhood in Connecticut, nights on the sleeping porch. Purple and white lilac hugged the northwest corner of our house and touched the screened porch where we spent carefree June nights. One breath

and I am young and there again. Gardenias remind me of my first date at Trader Vic's when I was sixteen, sipping a pineapple delight. What scent associations do you recall with pleasure? They will fuel your sense of fantasy and help make you feel calm.

Jane E. Brody, the "Personal Health" writer for the New York *Times,* has written about the newly discovered impact of light on health. People have worshiped the sun since the beginning of time, but scientists are just now discovering that sun and light have health benefits far beyond those imagined even as recently as four years ago.

Light is restoring to the soul; it has a tremendous effect on one's moods and behavior. Many people feel the mood-elevating effects of sunlight, and feel glum in winter when it is in shorter supply. I believe health and environment are closely connected, and that it is important to bring a feeling of sunshine, fresh air, and light— almost like a garden—into your bedroom.

Brody's article points out that artificial light has only one-tenth the intensity of daylight under the shade of a tree in midsummer. Being indoors in winter amounts to being in a perpetual twilight zone. Now that scientists are understanding more about the effect light has on body and mind, they are "distressed by windowless offices, dim lights in public areas and the use of energy-efficient but spectrally restricted lighting in work areas." Dr. Richard Wurtman, a neuroendocrimologist at MIT and a pioneer in light studies, said "three major variables of light are now known to influence its effects: intensity, or how bright the light is; spectrum, or which colors are represented; and timing, both day and night and seasonal changes in the duration of light." Dr. H. Richard Blackwell, professor emeritus at Ohio State University, has found that "most indoor lighting diminishes visual effectiveness and, in turn, imppairs work ability." He believes light derived from near-equal bands of the visual spectrum could increase work productivity by 11.7 percent—which he describes as "a staggering amount."

I've found tungsten halogen 400-watt quartz bulbs are most ef-

fective. The lamp is a tall, thin shaft with a cup or saucer shape at the top; it spills light onto the ceiling and brightens up dark corners of rooms. These lamps come in brass, chrome and white, and are available through lighting outlets and department stores across the country. They come with a full-range dimmer. When the light is at its brightest it is white, and as you dim it, the light becomes warmer. The combination of regular incandescent lamplight and halogen light is, to me, ideal. Ordinary incandescent bulbs provide most of their radiation from the red end of the spectrum (ninety percent of the rays are infrared, which is why the lights are so hot). This gives a warm glow.

I recommend having an abundance of lights and plenty of brightness in your bedroom. You could have many of the lamps on dimmers, to increase your lighting options. "Tent" standing lamps are often used as reading lamps, but they only have 60-watt tubular bulbs, and I find that isn't enough light for reading; I'm more comfortable with 100 to 150 watts of light shining down on my book. Your choice should fit your individual lighting needs.

In any case, I'm convinced it is false economy not to have lots of light in winter. The New York *Times* article suggested that you keep the lights on in rooms you leave so when you reenter the room it will be warm and cheery. It costs money, but studies indicate it is preventative medicine. There is a rare emotional disorder called seasonal affective disorder, or SAD. As the days grow shorter each fall, people with SAD become increasingly depressed in the winter solstice when the sun is over the Tropic of Capricorn, which occurs about December 22. They suffer from irritability and anxiety, they are socially withdrawn and less interested in work and play— they're sleepy and they gain weight. SAD is a disorder I run away from. Light the lights!

The dying of the light at the winter solstice brought about many of the rituals and myths by which ancient men and women reconciled the terrors of nature with reason and hope. Rituals have symbolic and psychological roots—they calm fears; the pagans were the

first to light trees in the dark of winter. We, too, should make winter solstice rituals—light candles, fires and lamps to add gaiety and cheerfulness to the dark side of our year.

The Hansen brass swing-arm wall lamp, with three-way (50–150) switches has become a classic, and I use it in bedrooms with great success, placed on either side of the bed, to light a desk or dressing table, or at each end of a loveseat. Swing-arm lamps come with brass tubing that hides the wires and becomes an attractive design feature of the lamp. If renovation is planned, a special outlet called a gem box can be installed in the wall, so that no wires are visible. Standing lamps are useful because you can place them around without requiring a table as well. The styles of lighting you use will change according to taste preferences, but take your lighting needs seriously.

Once you're settled in bed, a bottle or pitcher of cool, fresh water with a drinking glass at your bedside is a simple luxury. Sipping

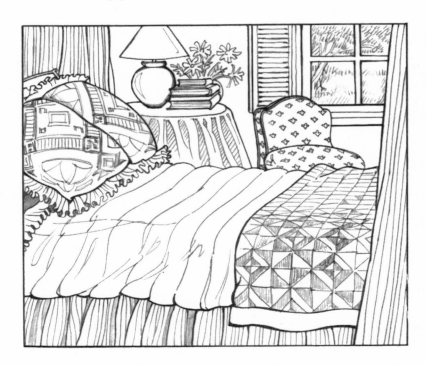

water is a satisfying health aid. I've seen crystal carafes decorated with hand-painted flowers that come with a matching glass which, when not in use, fits on top of the carafe like a lampshade on a lamp. Squirt in some fresh lemon or lime juice when in the mood, or add a paper-thin sliver of orange peel.

There is nothing cozier than drinking a hot toddy or a cup of weak tea in bed before going to sleep.

At 9:15 P.M. the other evening the telephone rang. We'd finished dinner, and I'd had a bath and retired to my bed for an evening of reading. My well-trained teenage daughter told the caller, "She's gone to bed." The next morning was soon enough 'to talk. Once I'm in bed I try to leave the outside world behind, and a telephone call brings it back into my bedroom.

Avoiding the telephone creates a great calmness in me. It's an essential form of business communication, but I need to turn it off to relax completely.

Being unavailable is a luxury; I don't indulge in it during "on" hours, but, unless something is done to prevent it, one can be on call twenty-four hours a day.

A favorite spot for our vacations is an island where there are no telephones in the cottages. After shedding clothes and settling into the gentle rhythms of island life, I unwind to the music of ocean waves and soft sounds. A jangling telephone would be an inappropriate intrusion.

An answering machine or service may give you peace of mind. Just knowing there will be uninterrupted moments of restfulness in which to dream and wonder and sleep . . ."The innocent sleep, Sleep that knits up the ravelled sleave of care . . . chief nourisher in life's feast."

Fresh air from an open window is a healthy thing to have while you are sleeping. And air conditioning can be a lifesaver when the available air is too hot and humid and there is no breeze. A room that is too dry is unhealthy, and doctors are recommending cold-

air humidifiers to reduce winter sore throats and sinus conditions. It is also a wonderful skin moisturizer. Silent humidifiers are now available.

Sleeping patterns are deep-rooted. How much light came into your room when you were a child may have something to do with your light tolerance while you sleep today. Frustrated, tired parents of a small child made their son's curtains blackout, so the child would sleep later in the morning. This seemingly innocent move caused the child to have a lifelong pattern of sleeping difficulty unless he is in a pitch-black room. We are all creatures of habit.

Generally most of us tend to be more receptive to sleep when it is dark outside, and we feel an awakening when it is light. Claude Monet felt nightfall was a mini-death. The hormonal effects of light influence reproductive cycles, sleeping and eating patterns and activity levels that are mediated through the brain's pineal gland. This gland secretes a hormone, melatonin, which is normally released at night and turned off during the day.

Everyone's sleeping patterns are unique, however, and their sleeping rituals should be, too. It's best to follow what works for you in search of a good night's sleep. I know a lady who carries safety pins with her when she travels, in order to pin the curtains closed. If need be, she makes swags out of terrycloth bath towels to block out light. A friend of mine travels with a machine that plugs into an outlet and makes sounds like rolling waves. This helps her go to sleep even in the dreariest of hotel rooms. Some people bring their own pillows when they travel.

Most of us are sensitive—in varying degrees—to light, air, sound and smell when sleeping.

Shutters are a good solution for windows, because you can adjust the louvers for privacy while still allowing air to flow through. Woven wooden blinds also work well, especially if they have been "privatized"; the back of the shade remains opaque yet still allows air passage. Levelor blinds, the modern, wafer-thin venetian blinds, now come in ½″ widths and are an inexpensive, useful way to

darken a room. They, too, allow for privacy and air circulation. Any decorative blind hung above a traditional double-hung window works well, because you can open your window a crack for air. The blind won't interfere—you don't have to lower it completely.

The bed is our ultimate security blanket. What is more important than where we spend one-third of our lives? The quality of your sleeping ritual is dependent on having the right bed. And many of us also use our beds as places to go to get away from the world. I often take to my bed for comfort. Your bed and mattress should be appropriate for you.

If you sleep alone, chances are you can find a bed the right length, width, height, firmness and style for your build and mood. You are free to select the perfect bed just for you. Sharing a bed can bring out all kinds of differences. A husband might need a firm mattress while his wife likes hers soft. Get separate boxsprings and mattresses attached together. It is to beds that we take all our emotional and psychological fatigue. The bed should be right for *both* people, even if their preferences are at odds.

My back has been my Achilles heel ever since my first child was born, and I know my present backaches are caused by fatigue and stress. A few years ago I designed a four-poster bed made of Canadian maple with beveled posts and big ball finials. Instead of using a traditional box spring and hair mattress, I inserted a Lattoflex system of wooden slats with a firm 4″ rubber mattress. Our queen-size four-poster is outfitted with two mattresses and two separate Lattoflex systems, one for Peter and one for me. Once I started using it, my backaches immediately vanished. Anyone with back trouble should sleep on an individual mattress that supports his or her back. I heartily recommend Lattoflex, which I tried because so many clients specified they preferred this bed system. Dancers especially, whose livelihood depends on their backs being pain-free, often use Lattoflex. Large furniture stores usually have a Lattoflex system available for examination.

Try to place the bed so that it is a distance away from the door

and in a position so that you can see out the windows but the neighbors can't easily see you. There is usually one ideal place for the bed in the bedroom, and a floor plan isn't always an accurate aid. You might place your bed to the left of the doorway in the plan, when in fact, if you did, you'd be staring into your neighbor's living room! On the plan it could look as if you nearly trip over the bed as you enter your bedroom, but when you're in bed you see only the sky and the water, and your neighbor is out of sight. Far better. Always put the bed where it makes sense for you—where you have the best view, and the greatest amount of privacy.

A client has a small, square bedroom with windows on three walls; the fourth wall is taken up with closets and doors. "Where do we put the bed?" The theory that there is always a right place for the bed was being tested. Almost any solution would have some awkwardness about it, and so we got daring and placed a four-poster bed in the center of the room. This bedroom is one of the most sensuous, warm rooms I've ever seen. The bed invites.

Once the mattress is comforting and supports you, the bed should be aesthetically pleasing. Mrs. Winston Guest was once quoted as saying, "All one really needs is a divinely attractive bed."

The appearance of crisp, embroidered linen, the cool feel of well-ironed cotton sheets, the scent of spring flowers, all add up to making the bed a sacred, cozy, irresistible place. The more attractive the bed, the more soothing and relaxing the bedroom experience. Your bed should hold special meaning for you.

White has always been the classic color for bed linen, partly because it is timeless, and has natural associations with purity. Soft pastels can be equally enchanting, but I don't think bed linen should be strong or aggressively patterned. Pastel patterns are nice, but I feel pure white is ultimately the most elegant. I enjoy switching from white sheets combined with flower-patterned baby pillows to pastel sheets and white, lacy, scalloped and ruffled baby pillows.

It's fun to have variety in the way your bed looks—not just in the sheets you use but also in the blanket covers and quilts. Heavy

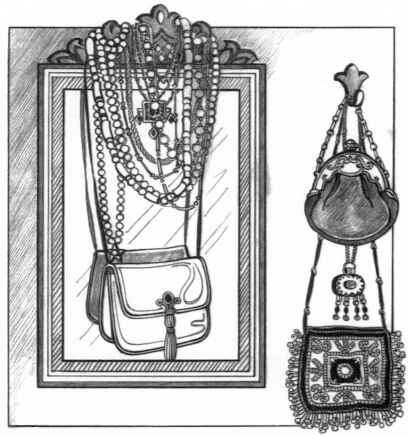

bedspreads aren't necessary; light coverlets that are machine washable are easy and attractive. It shouldn't require two people to make a bed. A goose-down comforter, usually called a duvet—the French word means "down" or "fluff"—is lightweight and can be slipcovered in a variety of sheets or fabrics. I like to throw an old patchwork quilt at the foot of our bed; it gives the room color and it's there to pull up over you for a nap. Mohair and cashmere pastel throws are also inviting, and can be placed at the bottom of the bed or on a chair or sofa nearby.

The feel and smell of a sheet, as well as the way it looks, is tremendously important. There is a trend in America today toward using natural fibers. Some synthetic materials scratch and can actually irritate your skin; I've had drip-dry sheets that smelled syn-

thetic. Because we often buy sheets packed in plastic covers, we can't touch or smell them until it's too late. Buy a pillowcase and give it a try before you invest in a whole bed set and end up with sheets that aren't pleasing to the senses. Cotton and flannel sheets, which smell and feel fresh, soft and inviting, are also practical. You can use a flannel top sheet as a light blanket; flannel doesn't need to be ironed.

If you love beautiful bed pillows, as I do, stack them two or three deep against the headboard and use the ones hidden in back for sleeping, so the ones in the front stay fresh and unwrinkled, for show. We have eleven pillows on our bed—and I wouldn't give any of them up! Pillows aren't just for sleeping—a well-dressed bed has a generous display of pretty pillows. Consumers spent $250 million on sleeping pillows last year and $125 million more on decorative pillows—pillows are a big part of bed rituals!

Pillows come in a variety of shapes and sizes: standard and king size, large square, neck rolls and boudoir or baby size. A combination of all four sizes and shapes is attractive and gives you a great many options for bedtime comfort. Fiber-filled pillows are practical for your decorative pillows because they are inexpensive and hold their shape, but most of my clients (unless they have allergies) prefer goose down for sleeping.

If your bed has rails for bed hangings, change the hangings regularly, too. My four-poster has movable finials so the rails lift off and you can slip on curtains and change them at a whim. In the winter you may want white and blue flannel sheets, with bed hangings to match; in the summer, gossamer-white embroidered Swiss curtains, which move in the breeze and are as fresh as the summer itself. Cotton is the preferable fabric.

Making a sumptuous bed is preparing a place for rest and leisure. After you change your bed linen, you might spray the pillows with cologne—or tuck sachets inside your pillow shams. The fresher the bed the easier it is to give in to sleep. Be sure you like the fragrance of the detergent you use; even pure cotton seems stale if your soap

powder has an unpleasant smell. I use one that is delicate and lemony. Sometimes it seems better to use a totally fragrance-free soap powder so that it won't clash with the other aromas. When the atmosphere around you is flowery, sensuous and enchanting, you can close your eyes and imagine you are in an Impressionist painting.

You have prepared a place and now you must prepare yourself.

Have a nice selection of intimate evening clothes—it's part of the fun of life, and of a ritual that can sustain you. Have some outfits to match the colors of your bedroom and bedding. Collect a variety, for different moods and seasons. Evenings alone are often times when couples can really appreciate each other and the way they look. Always wash new cotton nightgowns and pajamas before you sleep in them, to assure that they are soft and won't irritate your skin. I put on a new pair of pajamas recently and found myself scratching all night. Pure natural fibers are best because they breathe. Remember, if fifty percent of your time is spent in either solitude or intimacy, you should have almost as many attractive gowns and at-home costumes as you have career clothes and daytime clothes.

Most important is that you do things for your own enjoyment. William Sloane Coffin, the eloquent preacher, once said, "There is great joy in self-fulfillment." An evening alone in bed in a lovely nightgown could make your solitude an extra-special blessing.

Samuel Pepys often ended his diary entries with the words, contented as a sigh, "And so to bed."

Just as the food we eat affects our mood and personality, good sleep habits relate directly to the way we feel. When I'm edgy, frustrated and discouraged, a beautiful night's sleep is often the cure.

William Lyon Phelps, professor of English literature at Yale, told one of his classes, "Let the walls of your mind be filled with many beautiful pictures . . ." Before I go to sleep I love to give myself up to visualizing beauty. I conjure up a client's living room I love, or a

view I liked, or a place in France. David Hume tells us that "beauty in things exists in the mind which contemplates them." I can think of my daughters, Alexandra and Brooke, and be soothed immediately.

A client was pressing for a design solution from my mentor, Eleanor Brown, who just smiled and said, "I don't know the solution; I haven't dreamed on it yet."

Dream experts claim we dream for approximately twenty minutes at a time, usually about five times a night. It's the dream just before we awaken that we usually remember.

Dreams relate to what's going on in our lives, of course, and because we aren't in control of our dreams we can learn a great deal about ourselves by listening to them, to what they tell us about our subconscious. Yeats once borrowed a line from an old play: "In dreams begins responsibility."

Last July I was working with great intensity on a color project for a fabric house. I was under the gun of an approaching deadline: colors flashed before me in millions of kaleidoscopic shapes. My dreams were particularly vivid. One night, as people spoke, colors —pink, yellow, green, blue—came out of their mouths, instead of words. It was wonderful. Colors were speaking louder than words! Certainly my fierce immersion in the project when I was awake made it a real part of my dreams. I would wake up and almost run to my studio, where I would sort through literally thousands of different color gradations separated into baskets. The solutions to selecting attractive colors and distributing them appropriately in different patterns seemed to come immediately after dreaming, just as key words useful in my writing sometimes jump into my mind first thing in the morning.

Create rituals that allow your brain to rest quietly in your bedroom; this will help your dreams work for you in a positive way. I feel time spent simply resting helps settle me down, so that more creative ideas emerge.

A few weeks ago I awoke with a mild case of flu, and felt a bit under the weather. After leaving the doctor's office, I stopped by a magazine store and bought an armload of magazines. When I got home, I took out a new flannel nightgown, and put a clean pastel floral bathrobe (lined in terrycloth) and a set of fresh turquoise and pink sheets on the bed. I called a florist and had a purple hyacinth sent over.

Without realizing what I was doing at the time, I was preparing for a special trip—I was going to bed, and I was going to hang out there, in beauty and comfort, for a few days. My doctor had said I had flu, and instead of fighting it and the world, I gave in and decided to make the most of some quiet time. I sipped honey-drenched tea, thumbing through magazines—I felt too fuzzy-headed to do any serious reading at first. The phone was turned off. My bed, with its fresh color scheme, was a treat, and slowly I began to unwind, to sink into my pillows, and to realize the luxury of having a few days at home to relax in my pretty pastel bedroom. It became a time to appreciate my life. The wonderful atmosphere of home beats almost any other place! My special trip to bed was a treat, a nourishing ritual, and as a result my mild case of flu left me feeling more relaxed and in better shape than before I got sick.

Slowing down and having free time alone allowed me to do a lot of things my daily life doesn't usually allow. I read all the new magazines and went through dozens of old ones, too. Eventually, inspiration struck, and after a few days I wrote an article for an antiques catalogue.

Make a ritual of being slightly under the weather!

I always set the alarm clock for twenty minutes earlier than I need to get up, so that I can linger and collect my thoughts, and so that the transition from sleeping to waking is less abrupt. Twenty minutes of transition time helps me get up on the right side of the bed.

Quiet and calm before the rush of a new day gives you time to reflect on your dreams and visualize the opportunities that lie ahead.

Friends of mine who have the strongest morning rituals are writers who need to tap into the ideas and images developed while they were asleep. Bob O'Brien, a senior editor of *Reader's Digest* and author of eight books, advised me not to read the New York *Times* first thing in the morning. The first hours should be spent being creative.

Having time alone in the morning upon awakening is a daily ritual for most busy people. A mother of small children gets up before her family so she has some quiet moments. A husband might slip into the library and exercise alone. Whatever the rhythms of

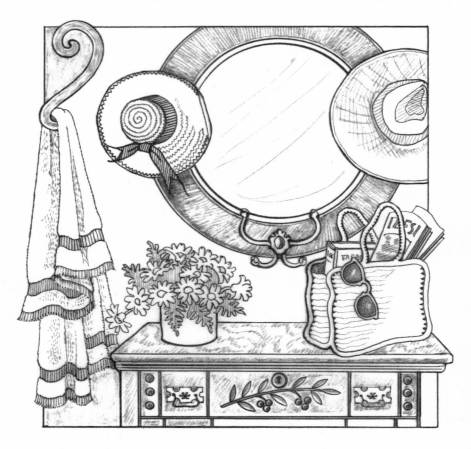

your daily schedule, be sure you give yourself enough time to have meaningful waking rituals. Having to rush and not taking time to think about the birth of a new day is getting out of bed on the wrong side. Whether you read, write in your journal, meditate or sketch, your morning rituals should be carefully guarded.

GRACE NOTES

• Keep a journal by your bed to jot down entries before or after sleeping—what you remember from your dreams—before you get up. Make this a daily ritual. I keep a pocket flashlight by my bed, in case of emergency but also in case I awaken in the night with a brainstorm.

• Caswell-Massey sells fragrant burning oil and Floris rings; you can place these rings, filled with oil, on top of your light bulb. A few drops of orange-blossom oil on a Floris ring—and the room smells like an orange grove as soon as you turn on your lamp! Change your scent when you change your sheets.

• Unplug the television and take it out of the bedroom! My personal preference is to keep the realities of the twentieth-century world out of this place of rest. Your bedroom rituals require calm to counterbalance the stress of the day.

• Make a ritual of turning your mattress once a month and switching the head of the mattress to the foot on odd months.

• Have your local tailor, seamstress or upholsterer re-cover your sleeping pillows with fresh muslin and rejuvenate the down as an annual ritual.

• Having a fresh cotton rug next to the bed is a nice touch. Many people, I find, prefer wall-to-wall carpeting in the bedroom to wood floors with area rugs, because the carpeting feels cozy on bare feet. We have bleached oak floors—mostly bare, with small, hooked rugs on either side of the bed. This contributes to a mood of leisure that suits us—I feel as if I'm in a broom-swept beach house.

• Use wicker for wastebaskets, and as containers for plants, maga-

zines and books. Spray-paint them white, perhaps even hand-paint them with pastel-colored flowers. Line a basket for sewing, knitting or needlework with a piece of pastel-printed cotton fabric. Make a ritual of doing handwork.

• Have an English mohair throw woven in a rainbow of yarns to match your bedroom chintz, and add colorful ribbons woven in rows near the fringed ends.

• Hunt around for an old American appliqué quilt to fold at the foot of your bed. Get two, and make a ritual of changing the quilts seasonally.

• Create a sitting area in the bedroom—a love seat, chair and ottoman are nice. If necessary, build storage space for clothes in the closet, so you can eliminate chests of drawers—a bedroom is a lovely place in which to sit, as a morning and evening ritual.

• Line your bed curtains in a bold striped chintz that coordinates with your curtains. You will touch and see this lining each morning as you open your curtains to a new day.

• You can freshen up any room by installing new brass hardware —hinges, doorknobs and key escutcheons—on doors and windows. Lacquer-coat the pieces so they keep their shine. If your old hardware is solid brass, strip it and have it lacquered.

• Consider a four-poster bed. To many, this is the ultimate bed luxury and offers opportunities for fantasy and romance.

• Have a dictionary near your bed along with a pad of notepaper and a cup of marbleized pencils. The bedroom is far from an office but you shouldn't have to leave it to look up a word. "Do it now" is possible when you're prepared.

• Have a rocking chair in the bedroom. Rocking soothes, and can be a great ritual.

• Drape a pastel patchwork quilt over a table, and add a white plaster bean-pot lamp. Hide a storage cabinet underneath. Rituals are meant to give peace of mind as well as pleasure. Being able to file something away without leaving your inner sanctuary is a treat.

• Have a small refrigerator in your closet for fruit, ice, Perrier and chilled glasses.

• Keep a kaleidoscope on your desk or your bedside table for spontaneous inspiration. Museum gift shops usually sell the most interesting ones.

• Buy a Tizio lamp for your end table and use it as a reading lamp next to your bed. They come in white or black; it has a halogen bulb; it swings, adjusts and gives you bright light.

• Read poetry before falling asleep or before you read the newspaper in the morning. Your last thoughts and your new thoughts should be expanding, full of hope, beauty and love.

• Frame a postcard you treasure in an adjustable frame and put it on your bedside table. I have Claude Monet's "Woman with a Parasol" next to my bed. Change the picture according to your mood.

• Before you get out of bed, stretch both legs—one, then the other. Stretch your arms. After you do this for a few minutes, you'll be ready to spring out of bed and embrace the day.

YOUR OWN GRACE NOTES

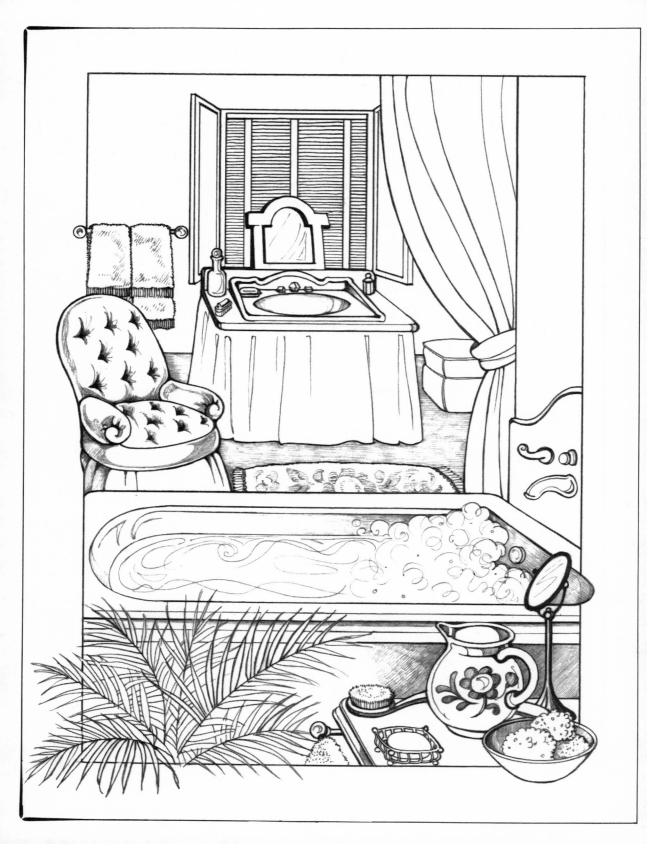

CHAPTER 5

THE BATH: YOUR OWN
PRIVATE OASIS

No man is a hypocrite in his own pleasures.
JAMES BOSWELL,
Life of Johnson, *June 1784*

Think what a miracle it is that most of us have running water in a room right where we live. The healing properties of water have been known almost forever—they were described in a report in Sanskrit, dating from 4,000 B.C. Today we enjoy a luxury kings and queens throughout history had to suffer without: water is available to us just by turning on a tap. And water cleanses, soothes, restores. It carries with it an image of new being and new life.

The bathroom was originally designed to be purely functional; now it is a place for pleasure and luxury. One room away from your bed you can have your own spa with running water, like a garden with a fountain, where you can refresh and renew yourself.

Water play, in the privacy of a room with a door, allows us freedom to recapture the child in us, and to create moments of heightened awareness. Winston Churchill, according to his valet, adored water play as a morning ritual.

King Minos built his palace at Knossos, Crete, 2,000 years before Christ, and he installed an ingenious system of baths, sinks, water-closets and cisterns, all linked with terra-cotta pipes and bearing

123

three separate water lines—one for waste, one for washing and one to provide drinking water. The Cretans bathed regularly, but they were the exceptions in Greece. The Athenians scorned private, domestic luxury: cold baths were taken only after athletic contests. The ancients considered bathing a ritual, not a routine, and believed they were washing away sins, not dirt. And the Victorians, especially the social workers of the period, believed washing was the baptism through which the common man had to pass before he could improve both his social condition and his mind, thereby also saving his soul. The Hindus wash three or more times a day, and in Southeast Asia water is credited with spiritual qualities and is thought to produce purity, wealth and fertility.

The Romans became a mercantile and a military power, and with increased prosperity and peace Rome's citizens were encouraged to develop an agreeable way of life. Domestic comforts were as much enjoyed as aesthetic pleasures, but the bath—an afternoon ritual for most Romans—was a public event, and Rome was famous for them. The Roman engineers were extremely advanced, and mastered the art of transporting water over long distances; in fact, some of the lead piping used in Roman times has survived in working order into the twentieth century.

One of the highest ideals of Roman life was "a sound mind in a sound body." The Romans maintained that a healthy, clean, beautiful physique was an essential. This society's self-confidence was a tribute to the earthly body, which had achieved such cultural wonders.

Pompeii, the ancient city of Campania, fourteen miles southeast of Naples, was destroyed, buried in ashes, by an eruption of Mount Vesuvius in A.D. 79. Modern excavations have uncovered part of it, and the pageantry of the bath ritual, the provisions for food and drink, the bathing ceremonies that took place in this highly advanced, sophisticated society are fascinating. There is obviously something here for us to learn in our own bathing rituals.

In the thirteenth century, England's King John bathed once every

three weeks. People of quality who had many servants made an elaborate ritual of bathing, with all the accompanying paraphernalia of rosewater, napkins and large ornamental ewers. Because considerable labor was required in order to bathe the entire body—the tubs had to be constantly replenished—bathing took place quite infrequently. When it did, the whole family joined in the bath-day ritual, and this, to us, basic human activity became a grand celebration. Bathtime was accompanied by food and music and afterwards, in all likelihood, love. In the sixteenth century, England's Queen Elizabeth had one bath a month, whether she needed it or not, and during her reign a flushing water closet was invented.

Crusaders returning to Europe reported on the luxurious habits of the Turks, and Turkish-style steam baths became quite common in London and Paris at the end of the fourteenth century. This was the first time hot water had become plentiful since the Roman occupation.

The reign of Louis XIV, France's magnificent Sun King, was a time of enlightenment. His court initiated a revolution in manners that led the world into a new kind of civilization. His courtiers would say of outsiders, "They do not know how to live." The finest craftsmen were hired to create beauty in the least glamorous articles of everyday life—the shaving table, the bidet and the chamber pot all became works of art. The Palace of Versailles, built to the Sun King's own design, has over one hundred bathrooms! Yet at the accession of Queen Victoria in England in 1837 there was not a single bathroom in Buckingham Palace. A bath was installed in Washington's White House in 1851, and by 1880 one out of every six American homes had a bathroom.

Bath, England, maintained a modest reputation for its mineral waters—the town dates from well before the Roman conquest and boasted the hottest springs in Britain. Ironically, the great bath built by the Romans in the first century A.D. was not found and excavated until 1878. Bath is one of the original spas, a city built for pleasure and in search of health. During the eighteenth century, visitors were

helped into a yellow linen garment—guaranteed not to cling when wet—and a cap, and they soaked for an hour in the steamy waters, gossiping and scrubbing themselves.

More insights occur in this magical room with running water than many accomplished men and women dare admit. Stunning concepts and wonderful ideas have been discovered in the bathroom— Einstein's theory of relativity, for one. It is widely assumed that his world-shaking breakthrough occurred while he was shaving.

Such things often happen after you've made an intense effort and then relaxed, seeming to be thinking of something else. Dawn comes, bells ring, we see the light. And as we go through our everyday routines—shave, shampoo, put on lotions, brush teeth— we often receive startling insights into our lives and work. When you wash your face you don't have to think about it; the mind is free to wander into loftier realms. Make sure all the tiny details in your bathroom suit you, because, when the bathing ritual goes smoothly, what you are doing doesn't get in the way of imagination and creativity. Don't shortchange yourself by not making provisions for meaningful time spent in your bath.

There are times when the bathroom seems to be the only place I can go to shut out hectic household demands, the pressures and tensions of the outside world. The bed is one retreat, but the bathroom becomes an inner sanctuary within an inner sanctuary.

Make this little room with running water an "idea room"—a place to go to be alone and uninterrupted, to free-associate and think. Running water calms, soothes, fires your thoughts. A harried New York *Times* reporter confessed to me not long ago that she has been known to have up to five warm soaks in the tub a day. Katharine Hepburn also is said to take many baths. There is something refreshing in hearing the cascading water flow into the tub, in feeling it splashing on your body. The temperature and sparkle stimulates, invigorates and clears the head—as a spring rain clears

the air. An entrepreneur I admire makes his transition from business to home by soaking in a hot tub as soon as he can after he returns from work. This is a daily ritual for him.

How can you enrich this room and your time in it?

The bathing ritual provides another opportunity to stimulate your sense of touch, sight, sound, your appreciation of good smells. The human brain devotes a disproportionately large amount of its space to olfaction—much larger than the amount given to vision. Developing your olfactory awareness enhances life, as fragrance adds to your enjoyment of flowers. Fragrance surrounds our lives —we wake up, wash, shave, shower, bathe, shampoo and make up in it. After we've washed in our favorite fragrance, we rinse our clothes and dishes with scented liquids. The creams, lotions, sachets, soaps, bath oils, salts, foams, talcums, colognes, perfumes and splashes are all simple yet often subtle ways to vitalize the living process and communicate delicately with ourselves and others. Nothing equals the unexpected pleasure of a lovely perfume; it can enrich the most ordinary occasion—especially in the bath.

Some ten years ago I discovered an almond cold-cream soap at Caswell-Massey, the oldest pharmacy in America (established in 1752). The smooth white oval thrilled me, and I've used this particular soap ever since.

My older daughter and I were having a bath together—Alexandra was about six—when she too discovered the pleasures of a sublime bar of soap. Smelling it, she said, "Mommy, I *love* this soap. May I take it to my own bathroom?" This was the beginning, for her, of no small pleasure in life. By using favorite soaps for your bathing ritual, you can awaken your senses to a new state of awareness. This pleasure is intimate, personal and unexpected—a small detail that can make you happy.

On one of our family trips through France, we visited a treasured spot near Grasse, the perfume center of the world. We went to several perfumeries to watch flower petals turn into perfume and see soaps and powders being created. At Molinard we saw a snow-

white cream being made from nutritive *antirides,* with a base of *d'huile douce d'amandes et de citron.* At the end of our tour we were invited to purchase some of the famous specialties, and naturally this cream was something we had to try. It is made of wrinkle-preventing nutritives, including almonds, rose-hip water and lemons. Pure and lovely. We bought a tube of Crème 24, and in the car on our way back to our inn we tried this all-purpose cream. We were hooked!

Back in New York I looked everywhere for Crème 24 without success; Caswell-Massey finally said they would order a box for me.

I thought I had been the first to discover this magical product, which is still not available in American stores. Yet Eleanor Brown had made the same discovery some sixty years ago. I brought her a tube of Crème 24 one day when I went to visit her. "Oh, Sandie," she said, "I have a jar of that in the refrigerator! I've been using it *forever.*" To this day her friends and family bring her large pots of Molinard's wonderful crème back from Paris.

Like Chanel No. 5, Crème 24 is a perfect product. The smell is delightfully fresh and appealing, but equally enticing is the smooth texture, and the way it softens the skin. Applying it to hands, face, arms and legs feels good and satisfies one's sense of touch. Roughness vanishes; this pure white crème soothes the skin and truly cleanses.

Enormous enjoyment can be gained from turning necessity into a sensuous act. The shape, size, form, texture and smell of things you buy are all component parts that combine with you and your body to become a pleasurable experience.

My father used to be vice president of Elizabeth Arden, and when I was a little girl growing up in Connecticut, our medicine and linen closets were filled with Blue Grass and all the Arden creams, lotions and powders.

There are good basic products that are easy on the budget—

Jergens Lotion and Johnson's baby powder both carry a strong scent association. I have a friend who told me how she once smelled her hands in a business meeting, and recognized the aroma of Johnson's baby powder; it made her happy, because it made her think of her baby son. And if you want to splurge, treat youself to Chanel #5, #19 or #22 body cream, each colored in a way that links up with its own individual scent.

Experimenting is a big part of the adventure. Try to use each bath product you buy as an opportunity to add a little luxury to your life.

Stedman's Medical Dictionary defines "rejuvenescence" as "renewal of youth." It's easier to feel young, to renew one's youth, if you maintain a supple, healthy body. Rituals for weight control, exercise and self-care gives us energy to live.

The bathroom can be a physical and psychological place, one in which we rejuvenate our bodies while our minds are free to wander into more fantastic realms. The bathroom is where most of us weigh ourselves, and where we return to bathe after exercise. It can also be a room you associate with rituals of health and rejuvenescence.

Jane Brody points out in her *Guide to Personal Health* that more than ninety percent of dieters regain the weight they lose. The only way to really control your weight is by the daily monitoring of what you eat. If you want to lose weight, you must eat less. It takes discipline, an attitude of ritual (habit) and moderation.

Last summer Peter and I spent two weeks in the South of France, eating in wonderful restaurants. We returned home and discovered each of us had lost a pound! None of our friends could believe it and wanted to know our secret. I realized it was because the food was so perfect, so beautiful and so artistically prepared, that we hadn't needed to eat very much in order to feel satisfied. We ate

small portions, but *tasted* everything; it was a good lesson in how quality nourishes us in so many ways.

Over half the food available in America today is processed. We are the most affluent country in the world, and the fattest. Forty percent of the population—eighty million of us—are twenty or more pounds overweight.

The way we eat is as important as what we eat (see Chapter 3). Making each eating experience meaningful and satisfying, creating an aesthetically pleasing setting for meals, helps us eat more slowly, consume less and feel better—more radiant, and happier about ourselves.

When I'm alone and undressed, I pause in the bathroom in front of a full-length mirror, and before I step into a warm tub I see the truth about my body—whether or not I need to lose a pound or two.

Think of your weight and shape as yours for a lifetime, and adopt a lifetime plan—one in which you eat nutritiously and have a varied diet that is low in fat and high in fiber. Diet has to become a daily ritual. So much of our lives is habit—things flow more smoothly when we have firmly established patterns, and rituals are, in part, the forming of good habits. By controlling your eating behavior you can control your weight, too.

A friend of mine in her mid-forties found herself unable to pull in her stomach; the largest clothes in her closet were too tight. After two weeks of anguish, disgust and dieting, she bought a good German-made scale. On September 1 she got on the scale and received a shock. Four years had gone by since she'd last weighed in, and she'd gained eighteen pounds. This was after dieting for two weeks!

Suzanne developed a plan. When she'd lost eighteen pounds, and was able to maintain her ideal weight of 130, she admitted to me that she has never cheated herself since she faced reality. "I weigh in every morning before breakfast and I keep a chart. I've discovered that by eating fresh fish, vegetables, fruit and more fiber, and by eating them slowly, I satisfy my hunger and cravings and

can maintain my weight. I had to change my eating habits—no snacks, no chocolate fits, no more second helpings, no more bread." Suzanne created meaningful eating rituals, and found that by being conscious of what she was putting into her mouth, she was able to control her weight.

Overweight people tend to eat very rapidly. If you have a tendency to eat too fast and chew too quickly, create eating rituals that will help you modify your behavior. Cut food into small pieces, and put the fork or spoon down between bites. Use chopsticks! This automatically slows down the pace of eating. Remember it takes twenty minutes for the satiation center in the brain to register satisfaction and a feeling of fullness; after twenty minutes of eating slowly, you'll start to feel the effects of the food.

Pamper yourself with sensuous delights: gowns and robes. This will make it less likely that you'll spoil feeling good about yourself by overeating. According to Dr. Albert Stunkard, a psychiatrist at the University of Pennsylvania who developed a behavior-modification scheme for weight loss, behavioral techniques can be applied by anyone anywhere. He suggests making your eating experience meaningful and satisfying, concentrating on the sight, smell, texture and taste of your food.

We're told that the best way to maintain good health is to consume a wide variety of foods, and to cut way down on fat and animal protein because most fat is nutritionally superfluous. Polyunsaturated fats (vegetable fats) tend to reduce the amount of cholesterol carried in the blood, and so they are preferable to animal fat, which does contain large amounts of cholesterol. Jane Brody refers to polyunsaturates as "artery-sparing." She warns us that most of the fat and sugar in our diets is "hidden," like the oil in nuts and avocados and the sugar in processed food.

Carbohydrates are the body's main source of energy. Starchy foods contain fiber or roughage—noncaloric undigestible plant materials that aid digestion. All-Bran or 100% Bran head the fiber list. Potatoes, rice, pasta, corn, beans and high-fiber bread can actually help you lose weight when they are substituted for animal protein. My friend David lost twenty pounds when he fell in love with an Italian woman who cooked pasta for him and wouldn't let him eat red meat!

The most important substance we consume is water, because, depending on our fat and muscles, our bodies are between fifty-five to seventy-five percent water. Newborn babies are seventy-five to fifty-five percent water. Many of the common foods we eat are mostly water, with lettuce, zucchini, watercress, watermelon, cantaloupe, strawberries, raw carrots, broccoli and grapefruit heading the list. Make a ritual of incorporating these watery foods into your daily diet.

The average American consumer uses two to five teaspoons of

salt a day, a total of fifteen pounds per person a year; even if you don't salt your food you have more sodium in it than you are aware. Stay away from smoked and canned foods. Replace salt in cooking with garlic, onions, lemons and herbs.

Doctors have discovered that many of the agonies women experience before their menstrual period is due to retention of salt and water. Ten days before menstruation is expected, follow a low-salt diet to reduce swelling of the body tissues.

Ten years ago we didn't see men, women and children jogging around our city streets in running shorts—on a track, yes, but in New York City, on cement, down Fifth Avenue and up Park? But now everyone wants to be fit, and there is a real respect for keeping the body in shape. We are told that exercise triggers the release in the brain of a natural tranquilizing chemical, beta-endorphin. The result is a relief in the tension that prompts many people to overeat.

Jane Brody devotes between one and one-and-a-half hours a day to exercise. Brody finds exercise a great tension reliever and relaxer. "I get angry and frustrated less often and get over my destructive feelings more quickly than I used to when I exercised less regularly," she admits. When you exercise regularly, you can eat a normal diet and not gain weight.

The amount of energy we expend uses up calories, so vigorous exercise is crucial. Muscle tissue takes up less space than the same weight in fat; your weight may not actually change, but with regular exercise you can go down a dress or suit size or two.

We create our own physical exuberance. Doctors advise us to get enough physical exercise so that we can achieve cardiovascular exertion. To obtain energy we need to expend energy. Find pleasant ways to move your body, to stay fit and feel well.

As a teenager, I played tennis during the summers, sometimes for eight hours a day. Twenty-five years later, I sit for most of my life. I sit at my job. I sit to watch a movie. I sit in airplanes, in cars.

I sit at the beach. I sit in bed, then sleep. A few years ago, my body rebelled. I had returned from a business trip to Texas and was brushing my hair when suddenly my back went out. It was painful, I felt as if I were being tortured. After a while I was fine again, and forgot about my back. We flew to California to visit our daughters and stayed in San Francisco for a few days. I reached down to pick up a sweater from my suitcase and pulled my back out once more. I'd gotten busy, turned my body on to automatic pilot and run its engine into the ground. When your car collapses, you can abandon it; when your body falls apart, you and only you know about suffering.

I go to an exercise class that is based on the joy of movement. We dance to music—stretch, run, hop, jump and kick up our heels. The magic is that we make the challenge for ourselves, and because we are inventing our own movements, we don't overstretch or get hurt. Only once did I ever leave a class after one hour and not feel exhilarated; it turned out I was coming down with flu. I exercise regularly for my mind, body and spirit. My back has told me I can't afford not to!

Shirley MacLaine, in her book, *Out on a Limb,* says, "People have to take care of their bodies every day or they can wake up one

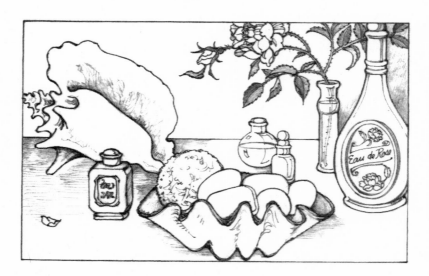

morning and find it won't do what they want it to. Then they'll say they are old. I always felt old when I was not in touch with my body. And the process of connecting with my body put me more in touch with the real 'me' inside of that body."

Take good care of yourself. Take every opportunity to exercise, and also to pamper your overstressed, highly pressured body. Strike a balance between exerting physical effort and indulging in soothing health and beauty rituals.

What is elegance? Soap and water!
CECIL BEATON

When I visited Knossos in Crete and saw, in the temple of Minos, the queen's terra-cotta bathtub, I noted in my journal that the basic shape of the bathtub hasn't changed much over the past 3,600 years. The reason for this is simple—the shape of the tub conforms to that of the human body. The Wadsworth Atheneum Museum in Hartford, Connecticut, has a red Egyptian porphyry Roman bathtub that dates back to the first century B.C. and is carved from a solid piece of stone. It is decorated with lion heads and with round, door-knocker–style handles at each end. The tubs we bathe in today may indeed be the same basic shape as their earlier Roman cousins, but are not as classical. In earlier times, tubs were often painted and decorated inside and out, as well as carved in relief. Louis XV's architect, Jacques François Blondel, advised using two tubs for bathing—one for washing and another for rinsing.

One of the reasons so many large men in the past have preferred a shower to a tub is that tubs used to be too small. Today tubs come as big as beds; we are all taking to the tub. As babies, our first pleasure was in touching our own bare skin. Our first communications were made through touch. Now we can go back to basics, and skinny-dip in our own private pool—the tub! A bath has always been able to calm and soothe me, lifting my spirit and

invigorating my body. A soak in the tub is a great way to begin and end a day.

Shirley MacLaine describes her love of her bathroom:

The bathroom was my favorite room. It was just adjacent to the dressing room on the other side of the terrace garden..A sunken square marble tub overlooked the rock waterfall where indirect light now played on the falling, dancing water in the evening light. . . . I leaned over and turned on the tub faucet. Warm water always made me feel better. Often, no matter where I was in the world, a tub of warm water could change my spirits into happiness. . . . Now as I simply held my hands under the warm flow I began to feel more relaxed.

I sighed to myself, climbed into the hot VitaBath soap suds. I thought of my mother. She loved hot baths too. I remembered how she'd sit in the tub and just think.

The Japanese have always been scrupulously clean. Traditionally Japanese baths are square and deep, big enough to hold several people at once. The communal bath is for soaking only—every bather washes meticulously before getting into it. Then the hot water is perfumed and medicated with flowers and seaweed and sulphur and soda. Fresh iris petals floating in the water are believed to bring happiness and health.

What does a simple bath cost? Assuming you are equipped with running water, which 94.6 percent of American homes are today, three cents for a squirt of bubble bath and you are in business. Yet a hot soak is a priceless luxury.

We are all still babies at heart—once in the tub we can play with the bubbles like a two-year-old. I think we enjoy the fun even more as grownups, because our lives are so riddled with tension—we often pay a price to be responsible adults. Baths keep the child in us alive.

We are free to be playful in our own bathtub. One father of three small boys explained, "I always grab one or more of my sons to have a bath with me because I have a better time with their toys

and their lack of inhibitions helps me to enjoy myself." When you take a bath with a small child, it is difficult to know who is having more fun!

The Latin word for bath is *balneum* and the term "balneology" is the study of bathing and medicinal springs—the therapeutic use of the bath. When you are submerged in water you lose ninety percent of your body weight and feel your body has lifted upward —when you float, you lose mental and physical heaviness. We all feel the satisfaction of a good long soak. Baths are indeed therapeutic—they soothe muscles, relax the body and stimulate circulation. At the end of a day, a warm bath has a soporific effect. When I have a bath just before I want to go to sleep I usually fall asleep effortlessly. Cold baths have a stimulating effect, but warm water allows us to unwind.

Bathing was the earliest treatment for mental illness. One cure for mental illness today is still alternating hot and cold water soaks, including herbal baths, compresses, barefoot walks in dewy grass, lots of exercise and a mostly vegetarian diet. This will wake up every one of your senses! Another cure is to have a lot of salt in the water—as much as there is in the Dead Sea.

What is the most luxurious kind of bath for you?

Caswell-Massey's almond oil bubble-bath gel gives mounds of puffy, fluffy white bubbles that are long-lasting and smell refreshing. I remember seeing *The Seven Year Itch* with Marilyn Monroe in 1955, when she was up to her chin in suds! A bubble bath is a joyous ritual.

I like to vary my bath ritual, depending on the season, the weather and how I feel. The scent of lemons always delights me in any form. I mentioned earlier my habit of squeezing citrus fruit into bath water. Another idea is to put herbs inside a small muslin bag—lavender, thyme and rosemary. Or add oatmeal for soft, milky water.

There are few reference books about how to create a wonderful bath, yet we take almost as many baths and spend nearly as much

time bathing as we do eating. To obtain the maximum benefits from a bath, statistics indicate we should soak for twenty to thirty minutes.

Plan bath "menus." Alternate between a VitaBath in the morning and a herbal soak in the evening. VitaBath comes in three scents (each a different color). Vary your herbal combinations. An English friend makes a muslin sack with cloves and cinnamon, drops it into the bath water, sips tea and reads while having her early evening bath. You can buy racks that sit across the tub to hold supplies, including a teacup. Add a mirror, and you can perform other cleansing and cosmetic rituals there. If you tend to take showers, a bath added to your rituals from time to time will make a wonderful change.

Water was so scarce in ancient Egypt that artificial showers were provided by pouring water from vases over the body. Early man refreshed himself at times under a waterfall. A painted Etruscan vase shows a pipe with a spout in the form of an animal head; the bathers, who have draped their clothing over the pipe, are having a shower. Yet it wasn't until 1846 that London had a proper shower bath!

The place where I occasionally swim indoors has a shower with dozens of showerheads, sprayers and water gadgets spraying water from all sides. All swimmers are expected to shower before entering the pool. I hate to leave this shower stall—the water applied with pressure feels so delicious. A shower is a different experience from a tub bath; you stand, so you can't relax completely. The water raining down from above exhilarates and awakens the body, and the steam opens and cleanses the pores. What could feel better after two sets of tennis than a hot shower? Where else would you rather wash your hair? Being in a tub is like sunbathing; the shower is like jogging. Three hundred gallons of water per person was used for a shower in ancient Rome; in London and the United States today, approximately 359 gallons are used per person.

In ancient and medieval households, hand washing before and

after meals became a formal and almost obligatory ritual. Homer and Chaucer often referred to the washing ritual in their writings. A servant, called the ewerer, would bring in a jug of scented water and pour it over the hands of those about to begin a meal.

The ritual of washing hands and face, shaving, brushing teeth and putting on makeup revolves around the sink. In the eighteenth century, cabinetmakers made a dainty portable tripod with a tiny china washbowl set into a polished wooden top. The sink became stationary once there was plumbing. Most bathroom sinks, just like kitchen ones, are too low. Stand up tall and your sink should hit you at the hip. We raised our bathroom sink from the standard 32 inches to 36 inches. People aren't all the same height; sinks shouldn't be, either. If you're renovating your bathroom, consider raising the sink to a height that is ideal for you. Buying a sink big enough to contain all your splashing doesn't cost more than a smaller model. Most sinks are too small for sink rituals. If you do plan to make improvements to your bathroom, don't pick a sink out of a plumber's catalogue. Go to a supplier where you can examine it personally, because the slope, depth and the way the sink is rimmed add to or take away from the pleasures of standing in front of it. Some sinks have a high lip so that water cascades down the outer edge of the sink, wets the whole counter and—if you lean against the front edge of the counter—you, too. Think how many years you will stand in front of this small procelain basin, and make sure it's just right.

Everything in our surroundings speaks for us, and if we accept living with a vulgar design we must pay for it. Caring about aesthetics increases your sensitivity. The more we care about the small details, the more in tune to beauty we become, and the more we realize how seemingly insignificant items affect us. You discover that by taking care of every inch of your surroundings you can let your eyes wander and not be caught short. We're free to open up to all there is in our surroundings. I get enormous pleasure and comfort from orderly, harmonious, attractive surroundings, and I feel

unhappy and disturbed when things are out of place, out of scale, or in bad taste. Let your eye be the judge. Train yourself to see things with caring perception.

Pierre Bonnard, the quintessential post-Impressionist artist, remained unhurried as he took in all the elements in a domestic scene. Scrutinize everything in your bathroom that goes to make up this little sanctuary. Are your faucets attractive? Do they feel good to the touch? It's not an expensive detail to fix.

The best light of all is daylight, so the artificial lighting you use in the bathroom should resemble it as closely as possible. This means incandescent lighting. Don't be persuaded to use fluorescent —it distorts and changes colors, especially in the bathroom; it's depressing and anything but flattering. There is no substitute for the good old-fashioned light bulb.

Consider putting your bathroom lights on a dimmer switch, because you will use this room when you are in different moods and at different times of day, and the lights should offer variety for your bathing rituals.

Men, because they need to shave, seem comfortable with a light over the sink; I think it's a shame to break up a large expanse of mirror with a light fixture, so I often suggest putting lights on each side of the sink—either swing-arm lamps or pretty sconces. If you do use a fixture centered on the mirror, a mirrored rectangular one is best. My decorating friend Georgina Fairholme likes to use theatrical lighting strips. Have separate switches for your ceiling and your wall lights. The light in a stall shower should be strong. Men now make a ritual of shaving in the shower because you can buy a spray that will keep the mirror from fogging up.

Order is restful; there is nothing particularly attractive about many personal supplies. Somewhere in the bathroom there should be ample cupboards for safely warehousing necessities; the linen closet

is usually too far away for extra toilet paper. Having nice objects out in sight enhances the bathing ritual, but most bathroom supplies should be tucked away.

It is often possible to build in extra storage, in addition to the medicine cabinet. A closed cabinet under the sink is practical, but if you can stow your necessary supplies in another place in the bathroom, having a floating sink counter is attractive. I sometimes suggest a tile sink counter, held up by crystal legs.

When we were renovating our bathroom, we were able to hide storage space inside an I-beam. By mirroring the front doors, we made the beam disappear into the adjacent wall mirrors. Being neat in small space requires discipline, but you will be rewarded by having an attractive bathroom. In our bathroom we each have two shelves for everyday use, and we use the two high shelves and the very low shelves for extra supplies. I keep stickers inside one cabinet for jotting down supplies before we run out.

Stock up on products you depend on. Shopping for toiletries can be an enjoyable relaxation, but when you're extremely busy, it's an extra frustration you don't need. Experimenting with new products is fun, as long as you have your old standbys handy as backups, giving you freedom of choice. And when you've found you're happy with certain brands of tissues or toilet paper, just stock up on them. Splurge on wild-cherry soap and coconut body cream and collect luxuries for your bathing rituals you can draw on when the mood hits you. We all know how to stock up on basics—be equally supplied with luxuries, because when purchased a few at a time, regularly, you hardly notice the expense and they are there for you when you want to create a special ritual.

Once all the necessary paraphernalia is out of sight, it is fun to do some staging, in this as in other rooms. A plastic Bic disposable razor should be kept out of sight, but an ivory-handled shaving brush makes an elegant addition to any bath counter. Old bottles in different colors, containing mouthwash, witch hazel and the like,

along with perfume bottles, can be attractive. Be strict with yourself, however, or you'll end up with a pile of clutter. Always weed out the excess once a week, so that you keep just a few quality objects in sight all the time.

Plants do well in bathrooms because of the moisture and because lights are frequently on. I keep a gardenia on my bathroom counter, and it makes the bathroom smell heavenly. On our tile window ledge we have two little pots of primroses—one pink and one yellow. Always have something in bloom in your bathroom. This requires an extra effort, but gives us back energy and enthusiasm.

Keep a round wicker basket full of natural uncut sea sponges next to the tub; these sponges are velvety soft, and you become one with nature when you hold them in your hand and squeeze them

underwater. On a small glass-and-brass table next to our tub we have a basket with an assortment of crystals, oils, beads, spices, herbs, gels, salts and soaps. A soap dish, a drinking cup, a flower container, a wastebasket, are all opportunities to raise a utilitarian object into a thing of beauty and quality. Wise Samuel Johnson reminds us, "There is nothing too little for so little a creature as man. It is by studying little things that we attain the great art of having as little misery and as much happiness as possible."

Bathrooms must have an attractive atmosphere in order for you to wish to spend time there creating meaningful rituals. If your bathroom is not inviting, you may avoid rituals that could otherwise give you a real lift.

A friend of mine went on a business trip to Dallas and stayed at a luxury hotel. The best feature of her stay was the elegant bathroom! During her fifteen-hour visit, Celia took three baths—simply for the pleasure of using all the oils and soaps set out, and so she could spend time in such an elegant little room. The luxury of the bath was in the details because, she realized, her bathroom at home was the same size.

Take a few steps back and look at the atmosphere of your bathroom; think about what you can do to make it more attractive and functional. Rituals are mysterious and satisfying; your daily rituals are intensely personal. Prepare the right elements to create the right ambience.

Take stock of all the hardware in your bathroom. As mentioned, it is usually possible to change the shower and tub handles without going to great expense. The hotel bathroom where Celia stayed had brass fixtures. Brass requires polishing, but some brass touches in a bathroom can warm the atmosphere. Celia also loved having a towel warmer in her hotel bathroom. An electric towel warmer may seem an extravagant luxury, but it isn't any big deal to install.

Towel holders should be long enough to hold two towels. A robe hook will always be used; be sure your robe is attractive, too! Celia's hotel provided a thick, white terrycloth robe; when Celia got home,

she added to her bathroom not only a big brass robe hook, but a fluffy white terrycloth robe as well.

Marble can transform a dreary little bathroom into a most appealing place. It adds texture and is nice to the touch.

Marble is organic and the veins are a natural property of the stone, so if you are considering marble for your bathroom, have a look at the entire slab. A dark streak in light marble can be unsettling when it shows up in an unfortunate place.

If you are considering combining tiles with marble, a white phosphorescent type works well because it doesn't have any surprises in the veins, and the shine of tile is pretty with the marble's sparkle.

Once you see decorative tiles at a store such as Country Floors in New York, you will long to have decorative tiles in your bathroom. If you have to replace tiles around the tub, make it an excuse to install some hand-baked, hand-painted ones. We had white French 4-inch tiles installed around our old tub. Seventy-five percent of them are white blanks and 25 percent are a variety of blue and yellow flowers, delicately painted. I appreciate every brush stroke; they enrich our pleasure in the bath. These tiles come in dozens of solid colors and make up into marvellous bath countertops. We have forest green around our sink. I just completed a blue-and-white bathroom where we used blue tiles with white grouting.

If you prefer marble or Corian (a white pressed marble) around the sink area, you can create a decorative tile border around the mirror. Or make a mirror more attractive by framing it with rectangular tiles.

If you are doing a more complete bathroom renovation, consider putting the tiles all the way up the walls. Recently we completed a bath with blue-and-yellow wall tiles checker-boarded up the walls. Their shiny sparkle and rich glaze add twinkle to this small room. I just finished a bathroom shared by two small boys, and we alternated large-scaled rectangular cobalt blue and white Finnish tiles on all four walls.

Most of us are deeply influenced and excited by color. One day

as I was walking home from work, up Madison Avenue, I saw a display of raspberry terrycloth towels in a store window. These towels were truly exciting to me because of their delicious color. But I already had a batch of mint-green towels. The solution was obvious—buy the raspberry towels and use them *with* the mint green!

If your bathroom is big enough to hold a small side chair, such as an antique pine one with a rush seat, stack up a neat pile of bath towels on it—a touch that can transform the room.

It's fun to use different colored towels for winter and summer. In summer use ones in the pastel range—white, lemon, soft pink, pale blue, lime and peach; combine the colors. Pure white towels, however, like bed linen, can be the ultimate luxury when they are blue-white and spotless. Clients who recently moved into a large, newly redesigned apartment built open shelves in the bathroom and keep a display of white towels there, with different styles of borders —his have medium blue-and-white-striped ribbon ones, and hers soft blue binding around the scalloping.

If your bathroom is tiny, mirror the walls in order to make it expand to seem a more gracious size. Mirrors are revealing—you see everything twice—yet they lighten, brighten and cheer the most ordinary bathroom. Hotels use generous amounts of mirror glass in bathrooms because they want a small bathroom to appear luxurious, and mirrors double space visually.

The mirror over our sink goes right down to our tiled countertop; and so when we place a picture in the bathroom, the back of the picture frame shows in the mirror. We love the way mirrors enlarge the room and fool the eye into endless space, but for every bottle we put on the counter it gives the image of two.

In order to keep a well organized bathroom for all your rituals, you must have ample space for your necessities. If you are creating a mirrored medicine cabinet, consider having the center panel stationary, with two side wings that hinge toward you as you face the mirror. This triptych allows you to see your profile, and the two

side wings can also house additional lighting, which helps in seeing to put on makeup.

Artists have always painted nudes—people in their less public moments, in unself-conscious absorption, in privacy. Of all the artists who paint the female nude, to me Bonnard is the most moving.

Bonnard's nudes are voluptuous and sensual; his art is both of the moment and of the ritual: everything has been caught as it happens. In 1893, when he was twenty-six, Bonnard met Maria Boursin and lived with her for forty-nine years. She was his model until her death in 1940. When Bonnard settled in the country at Le Cannet in 1925 they were married.

What touches me about Bonnard's painting of Maria is his appreciation of her character. Maria is said to have spent several hours a day performing her various ablutions, and it was with the bathroom as his background that Bonnard painted some of his finest works.

John Russell, the art critic for the New York *Times,* wrote the introduction to *Bonnard,* which was published to coincide with a recent exhibit of Bonnard's late works. Russell said Bonnard asked of Maria's body what he asked of the bathroom itself—that it should always be there, that he should be able to take it in at a glance when he opened the door, and that it should present him with a subject already defined. "The unlikely," he once remarked, "is often the truth."

Maria's haunting figure, so often depicted at her bath or immersed in self-absorbed preparation for some unknown ritual, aged, as all bodies do, but not in Bonnard's paintings. One senses the idealism, tenderness and dreams—the merging of memory and mystery. For twenty-one years Bonnard went back to the sight of a naked woman bent over in a little room that smelled of soap.

Russell said "everything is in [these paintings], if we know how to look for it . . . they are symphonies of a woman alone."

Bonnard's art celebrates not only Maria, but also the rituals of bathing. Your own bath rituals, too, can be transcendent, exalted, mystical. Rituals, and the time to enjoy them in the bathroom, cleanse away the cares and pressures of our lives. We are able, in our own way, to "wash right out of our hair" frustrations or irritations. Water cleanses the soul, lifts the spirit: we emerge rejuvenated, refreshed, clean and ready to begin again.

A friend reading my manuscript said that I have left out any reference to the crucial, if unromantic, flushing toilet: "I'm sure it's deliberate," she continued, "but the toilet itself *can* be made acceptable; it can be made something of an adornment, perhaps discreetly placed in a room by itself." Then she said, "I can never forget an old, old hotel in The Hague, where the lovely mahogany seat was splendidly polished by a thousand behinds, and the toilet bowl itself artistically figured with blue delftware flowers."

GRACE NOTES

• Have a perfume created just for you. Caswell-Massey will do it. For six thousand years perfume has been appreciated. Priests first used perfumes as offerings to the gods. Perfumes were used as healing oils.

• Dry the flower petals from your discarded bouquets and keep them in a pretty basket in the bathroom. Add drops of perfumed oil, and the moisture will enhance the fragrance.

• Bevel the edge of the mirror over the sink to add prisms of light and make lovely reflections in your bathroom.

• Raise the height of your sink so you can stand up straight and stretch. While brushing your teeth you can do deep knee bends!

• Install a wall-mounted portable shower. This hand spray can be used ritualistically to ease tense muscles and for some fun water play. Also good for spraying your plants.

- Buy or make terrycloth bath mitts to match your towels.
- Watch your spouse shave or shampoo.
- Treat yourself to a pedicure.
- Buy a thick terrycloth bathrobe. Put it on when you are wet from the tub and pat yourself dry. It is much better for your skin to pat it dry than to rub it.
- After an early evening bath, lie down for eight to ten minutes before you get dressed again. When I do this I feel like a new person.
- Install a pretty eyelet shower curtain, lined with a white vinyl one. Use grosgrain ribbon tied in bows to hook through the grommets of the lining over the shower rod.
- Get a professional scale and weigh yourself every morning before breakfast, after your exercise ritual. Store the scale in the closet.
- Before going to take a bath, lay out all your clothes, including jewelry. A leisurely bath ritual will be more restful if you have already envisioned the outfit you will put on afterwards. Putting on a blouse with a missing button or a stocking with a run in it wastes time and diminishes the benefits of restful bath. When your clothes are all set, dressing is quick and fun. Laying out clothes, the way my mother did for me when I was little, allows me to anticipate the next event with greater pleasure.
- Buy a bottle of Pine Spa oil, and once a week have a Pine Spa. Place the Pine Spa oil under hot running water, and light a pine-scented candle.
- Make a herbal bath ritual. Add peppermint, lemon, rose or jasmine tea, wrapped in a pretty cloth pouch and tied with a ribbon, to your warm bathwater.
- Create a pre-bath ritual using Neutrogena body oil, which is made of natural sesame seeds. Lather this oil all over your body before having a twenty-minute bath in warm water: it takes that long for your pores to open completely and release accumulated impurities and toxins in the skin.

- Hang a favorite picture in the bathroom so you can look at it while relaxing in your bath.
- Indulge in a new set of brightly colored terrycloth towels; be sure you include a six-foot towel to envelop yourself in after a hot bath. Choose ones that are super-absorbent, soft and vividly colored.
- Adorn your bathroom by putting Johnson's baby powder in a simple glass salt shaker with a brass top and use it after a bath.
- Display green and red mouthwash in glass bottles to add some color to your bathroom.
- Buy a pastel-colored bath pillow to cushion your head as you soak.

YOUR OWN GRACE NOTES

CHAPTER 6

CREATING A
LIFE WITH OTHERS

Creating meaningful personal rituals throughout the day eliminates the dullness of routine, enriches and elevates the events of our lives and at the same time comforts us. Rituals provide opportunities to define ourselves as humans; they are chances to appreciate and create beauty, to treasure the days of our lives, to make memories. We tend to forget the ordinary and the bland; we remember the special and the positive moments.

One of the important benefits we gain from such rituals is freedom. Paying attention to little details, putting things in order, frees you so that you can think more enriching thoughts. Rituals are pleasurable in themselves, and they also lift the spirit. The greatest advantage of having important personal rituals is sharing—and good rituals give you freedom to be more relaxed and open with others.

We long for the affection of others. Somehow one of the measures of how we are managing from day to day is the way others feel about us. Nobody wants to fade into insignificance. We all have things that speak especially to us; most of us want to make a contribution, to leave a personal mark. We are challenged to accomplish

what we can with what we've been given; to respect it and make the most of our talents, reaching out, loving and sharing.

Rituals enhance love because they are based on caring—and caring leads to sharing. We say to a friend, "Take care." When we take good care of ourselves we become free and we have more power and freedom to help others, directly or indirectly. An essential quality necessary for sharing is to be whole and personally responsible ourselves.

We care when our friends are fine and we worry and are concerned when they aren't. There are so many wonderful ways to share and express our warm feelings toward others. Do it as a natural part of your life, of your day. When you do things for yourself, include others in them. The next time you roast walnuts, roast some extra ones and wrap them to give to a friend you're meeting for lunch tomorrow. When you discover a wine you particularly enjoy, buy an extra bottle, tie it with a ribbon and bring it to a friend. Drop a few museum postcards off at a friend's apartment house on your way home from work with a note, "Thinking of you." After you've been to a special museum exhibit, take the catalogue to an elderly friend who is confined to her home.

Sharing doubles joy and diminishes sorrow; sharing is the natural next step after we have developed vital personal rituals. The richer our private lives, the greater our self-esteem, the more we have to give to others. When we feel good about ourselves we want to share. And, by sharing, we fulfill the greatness within us. Daily rituals, layer by layer, help us make the most of our gifts. Sharing requires participation; when we share, we give a portion of our gifts to someone else. Sharing can be done through rituals we create to reach out to others with love.

I believe what Robert Louis Stevenson said: "A friend is a present you give yourself." In the give-and-take of a healthy relationship, both people grow by the exchange. In the happiness of loving another, we feel better about ourselves, too.

Rituals require making an effort—and sharing also requires an

effort. In order to communicate that we care, we often have to actually *do* something—take action. Sharing can sometimes mean serving.

My godmother, Mitzi Christian, radiates a spirit that is infectious. When I am with her, I feel I am the most important person in her life! That's part of Mitzi's charm. Hundreds of other friends feel the same way, yet Mitzi is an independent survivor.

Mitzi lives a ritualistic life at home, and when she is with others she always seems more than ready to share her whole self with her large collection of friends. I have lots of my own friends who come to mind immediately as being naturally talented at sharing, people who have the power to give and who are determined to find life an adventure. I've known Mitzi all my life, however, and she is one of the sparkling examples of a strong, intelligent, feminine woman who has taken good care of her own rituals and is free to focus outward, radiating her enthusiasm and passions 360 degrees around her.

Mitzi understands that sharing is symbiotic—no matter how much excitement and satisfaction she generates through her love of family and home, painting, museum work, gardening and interior decorating, she has a generosity of spirit that moves her to remember a friend and do something thoughtful. There's nothing lazy about Mitzi. She once saw a Cézanne exhibit and thought about me; this led her to buy me the catalogue of the show and mail it to me with a note: "I wanted to share this lovely exhibit with you." Who doesn't want to be thought of? And how special we feel when someone we love expresses warm feelings toward us—out of the blue!

Mutual interests and pleasures help to sustain challenging, sharing relationships. If we give a portion of our inner selves to another when we share, we want the other person to be a kindred soul. We can share goals, beliefs, hopes and dreams, as well as more practical

projects. A married couple make a ritual of going to auctions on Saturdays so their time together will be more special. Another couple ritualistically goes to evening lectures at the Metropolitan Museum of Art so they can both learn something new; now they have begun an art collection. Conversations can double understanding. A mother and her teenage daughter went on diets at the same time and go to fitness classes together twice a week, ritualistically working toward shared goals. Friends formed a literary club to further their reading discipline, and meet one Sunday evening a month, for dinner and a discussion of the book they're reading. Rituals of friendship need interests and talents both partners enjoy. We can nourish each other with our enthusiasms.

One of the most meaningful challenges of my life was doing the interior design work for a bank in Texas. The bank became an important opportunity for wonderful shared experiences with the architects, the bank president, members of the board. When two or more people work toward something together, the project or event becomes "the third log," creating an excitement brighter and more intense than that shared by friends who have no special mutual concerns.

An editor helps shape a writer's book, a designer and an architect collaborate with a client to create a truly personal environment. Sharing is collaboration—a *joint* venture.

Sharing a sunset, a trip, dinner, the ballet or an art exhibit intensifies and magnifies these experiences, expands us and extends our ability to understand, to grow, to learn. Sharing silences is truly special and only possible when there is deep trust and love.

Edith Wharton, who wrote the first book about interior design in America, *The Decoration of Houses,* believed that friends are an expansion of one's soul; she wrote about "the joy of living." She said her friends gave her the ability to breathe real air.

Friends make our lives. Being someone's friend is a gift—we give back to a friend our own friendship. The amount of actual time we share with our friends has little to do with the quality of our caring.

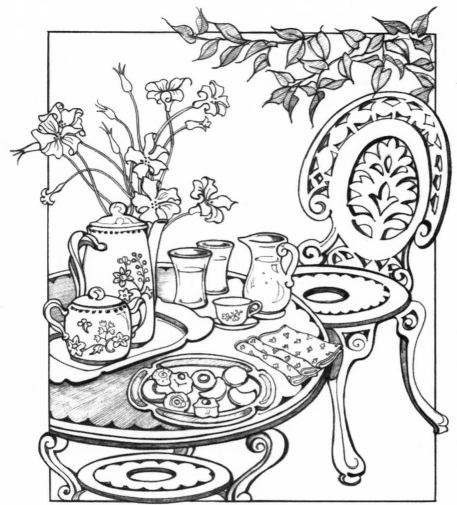

I have a friend, for example, who because of distance I only see every three to five years, yet I think of him frequently.

Friends give us the opportunity to move outside ourselves, yet to remain sincere and vulnerable. Emerson talked about friendship as entireness; Aristotle said friendship is the thing most necessary to life. Philosophers suggest we fill our friends' lives with sweetness, for friendship is the highest degree of perfection in society.

A Frenchman sitting next to an American on a flight to Paris struck up a conversation over lunch. The Frenchman had been in Michigan visiting his sister, who was ill and depressed; he had

asked her, "How many friends do you have?" Sadly, the answer came as a real shock: "One." Stunned, Jacques said, "Close your eyes and imagine a beautiful garden. Gardens take work—you have to cultivate your garden. Visualize each flower or tree as representing a friend. When you are ill and your spirits are down, you look out at your garden and see what you have. View your life as a garden. Your friends and your life take work and nurturing, but look at what you have."

Nancy is a friend who exemplifies someone who reaches out to others. She takes risks, she dares, she radiates a vital glow from all she shares with her friends. There is a special spirit to her sharing —she is spontaneous, yet you realize she puts everything that has gone on since she was born into the moment. As Keats put it, "Moments big as years!" When you're with Nancy, you feel she is feeding the moment, enhancing the occasion, making it happy and memorable. She gives and fuels times shared, so that you feel there is a unique quality in the air surrounding you. Nancy has that rare ability to focus her time so that it becomes like a snapshot in a scrapbook. Cancer almost got the best of her a few years ago, but now she's thriving, and I believe her attitude was what sustained her through a rough and frightening period.

We know how short and transitory our life is—I don't mean what the actuarial tables say about just how long we live, but how short it all is when we are alive, celebrating life together with those we love. We give a part of ourselves when we share, and each of us has something to share that no one else does.

Sharing rituals create special "moments of being." By living each one well, and by feeling connected to others through your own efforts and need to share, you extend those precious times.

There is an initial risk in sharing, but sharing is worth that risk. We can share material things or intangibles. It's a process that should develop into a natural daily habit. When we make these connections with others, we become part of a larger world and our

lives take on a deeper meaning. We touch and are in turn touched by the whole world.

I have a friend who must be one of the best listeners in the world. Others talk; Ellen listens; and because she is so gifted in the art of listening, she gets a real earful from her colleagues, family and friends. At lunch not long ago we were joined by two other friends, and Ellen concentrated on every word, occasionally asking questions. "I don't learn anything when I talk," she mused. "I read to learn and I listen to learn."

Listening is vital in a sharing relationship. We communicate our affection just as much by listening as by talking; developing good listening habits will put you more in touch with your friends and loved ones. Sometimes when we are feeling pressured all we need is to talk out our frustrations, or have someone share with us as we think out loud. Melina Mercouri once said, "In Greece we don't need psychiatrists because we have friends. They listen."

Mrs. Brown has been coming to us for Easter Sunday dinner since Alexandra and Brooke were babies. The Saturday before Easter, flowers would arrive, and on Sunday, Eleanor would appear at our door on the stroke of one with a two-pound box of Godiva chocolates: "Something sweet for the young." The girls were thrilled, and after dinner the gold box was opened and Mrs. Brown was offered the first piece. I'm sure Alexandra and Brooke would have liked it if Mrs. Brown grabbed the piece closest to her so they could have their turn, yet she would always gaze into the box, get her glasses out of her pocketbook and look at each design in sight. This became an Easter dinner ritual. Through the years the girls learned not to rush the process—there was delight in looking and wondering which piece held the most mouth-watering filling.

Now that Mrs. Brown is mostly confined to her home, friends know to bring flowers and Godiva chocolates when they visit! I once

made the mistake of bringing the wrong kind of chocolates. Mimi Sheraton had written an article for the New York *Times* on the wonders of chocolate and praised a new *chocolatier*. I rushed in to buy a box and brought it to my friend. I could tell she was a bit disappointed not to see the gold Godiva box!

Eleanor was a gracious hostess until she could no longer entertain. Now she says, "Peter, I can't give you dinner but I want you to have a chocolate."

We give what we can and what we have. Some of us are young in spirit—Alexandra and Brooke gave Mrs. Brown back the happiness of a touch of her own youth; she in turn gave the girls a glimpse of a dignified great lady who taught them there is pleasure in not rushing.

We give what we have, but we also give what we like. Eleanor Brown adores flowers and Godiva chocolates. She selects the things she has grown to appreciate the most and shares them with loved ones.

We develop a whole variety of ways to reach out to others, and the more successful the ritual the more new and satisfying opportunities you will find to give of yourself to those around you. Some-

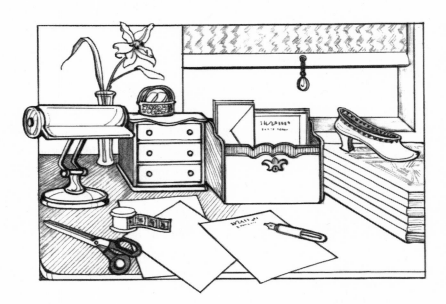

times you'll throw a party. Another time, set a place for a friend at your dinner table. It could be just a phone call, or a bar of pretty soap, or a smile; a pat on the shoulder or a hug—or a piece of Godiva chocolate!

We all love presents. Traditionally we've grown to expect a birthday or an anniversary present, but we are especially touched when we receive something out of the blue. Think of your gift-giving as bringing an unexpected pleasure to someone you care about. An element of surprise intensifies satisfaction. There is a double emotional impact when a present is given to you because someone thought of you, or came across a book that "has your name on it." Sometimes, during the holidays we get so caught up with lists of people we "need" to give presents to, that we forget the fun of suddenly giving a very personal present to someone for no good reason at all!

I keep large, pretty boxes on a shelf in my bedroom closet, and whenever I find little things I really like on my travels—baskets, fabric-covered boxes, potpourri, decorative soaps, notepaper, handkerchiefs, picture frames—I buy several and store them in my goodie boxes. This way I have my own supply of personally selected presents that, on occasion, I can give as surprise gifts to friends.

A writer and connoisseur doesn't give tangible gifts except on special occasions—yet each day Susan Victoria gives intangibles in abundance. Susan knows a wealth of fascinating people she's met through her writing and her travels, and her gift is in getting people together. Sharing ideas is something Susan loves to do, because she believes that when she shares ideas, her own creative energy is fueled and more ideas flow. Susan believes when you know someone well you have a pretty good notion about what they like—what their interests are—and you expand your own experience by sharing an exhibit, a meal, a play, and seeing these things through another person's impressions. Susan's untiring quest for adventure, beauty and excellence leads her to discover a new shop, to try the newest restaurant, to stumble upon a wonderful place to have after-

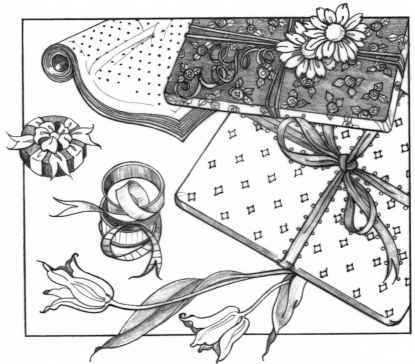

noon tea with a friend—and she shares her finds. It gives her pleasure to expose someone to something that might otherwise have been missed. Giving a contact, a resource, an idea is part of Susan's genius, and her friends count on her to tell them what they might not have seen or heard about that is worthwhile.

"When I discover empathetic friends whose enthusiasm feeds mine, I'm inspired to do more, to care more, and to go on with joy. Once I make a discovery I have to call my friends and spread the word—and this reinforces my need to care and my belief that excellence and quality are possible and truly matter in the smallest things and moments in our daily life."

A friend for over twenty-five years enjoys sharing his apartment. Bob Bushnell is a handsome, fun-loving bachelor who has a large, dramatic apartment on the thirtieth floor of a building with spectacular views of New York. Bob loves seeing his friends enjoy themselves, and he likes to share his apartment because, in his words, "it intensifies my appreciation and enjoyment of what I have."

Claude Monet would invite his artist friends to Giverny when the irises would be at their peak. He didn't want to enjoy this beauty alone.

Sharing requires someone to receive what you have to give. There is an art to receiving, and we should work at developing it. When someone reaches out to us, we should know how to respond.

Sharing is a habit; it improves with practice. It's fun to give, but as we develop our own style and patterns of giving we realize it goes much deeper—it enriches our life, so that every day on which we make a ritual of sharing becomes a special one.

GRACE NOTES

• Don't throw old catalogues and magazines out. Offer them to a friend, your hairdresser, a charity or a hospital. Let others enjoy them.

• Make a date to bake with a friend and give your goodies to someone who's having a hard time. Have a child help.

• Create a pretty emergency basket for the office—everyone can come and help themselves. Fill it with hand cream, needle and thread, stockings, spot remover, packages of chicken broth, a small pepper grinder, lipstick, cologne, a silver spoon, a plate, some colorful paper napkins, a cup and saucer, drinking glasses.

• When sending a gift package to a friend, wrap it beautifully and cover it with heavy-duty clear plastic: use colored Scotch tape to seal it with, and put your label and stamps on the see-through plastic. Give the postman a little fun—and the receiver, too.

• Buy several rolls of colorful grosgrain ribbon to have on hand when you want to make something ordinary special. Use pieces of it as bookmarks, or to tie a bow around a bottle of wine you give a friend. Save ribbons you receive throughout the year and put them in a see-through cookie jar for re-use.

• Make your own envelopes out of beautiful paper. Hand-border them with Magic Markers and glue with a glue stick.

• Buy a brass letter rack for your desk and fill it with your favorite stationery. You can also find them in leather or marbleized paper, and some old ones are made of wood.

• Stack art books on tables for friends to thumb through. Having books around the living room sparks conversations, and you're sharing something you like with your friends, too.

• Psychological tests prove that when you are smiling you feel better. Smile! You are giving happiness to others when they see you happy. Smiles are infectious.

• Volunteer to give your personal service to a charity you believe in, or a project; pitch in with enthusiasm and watch spirits rise.

• The next time you read and like a paperback, buy an extra copy and give it to a friend—someone you know will enjoy it, with a personal inscription from you.

• Buy *Gift from the Sea* by Ann Morrow Lindbergh and give it to a friend who is going through a difficult period.

• Write thank-you notes—immediately! One line promptly sent will be eagerly received. "I'm sorry I haven't written sooner" isn't good enough—we're *all* busy.

• Remove notepaper and envelopes from their box and tie a satin ribbon in a bow around them. Put this colorful gift on your desk, whetting your appetite to write a spontaneous line to a friend.

• Buy a pretty guest book and have your friends sign it when they come to visit. Memories are fifty percent of life!

• Give a party in honor of a friend. The process will bring you joy and you will touch someone deeply.

• Call a friend and set a date for tea for two.

• Make a special birthday scrapbook of photographs and memorabilia for someone you dearly love. If you can't find the negatives, a color lab will duplicate positive pictures.

• Begin a collection, for a niece or a godchild, of silver teaspoons gathered on your travels.

• Give a parent or an elderly friend a year's supply of flowering plants that arrive once a month.

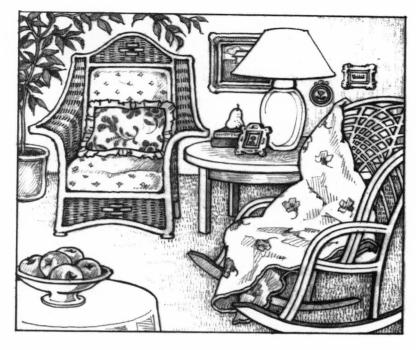

• Give a teddy bear to a friend—of any age. If that person feels "too old" for the teddy, he or she will pass it on to someone who will love it.

• The next time you go to a museum, buy two sets of postcards; put a ribbon around one and bring the museum home to someone else.

• Buy a blank book for a friend you know wants to begin a journal but has trouble getting started.

• Send a love letter through the mail to your spouse or child—someone who lives right there with you. It will come as a surprise. Leave little love notes around the house where you know they'll be found.

• No matter how old your children are, when they are living at home always have them come say goodnight after they get home from a date. Never miss an opportunity to share their experiences.

• Use the word "love" many times each day. A busy executive with five children told me he never went a day without telling his chil-

dren he loved them, right up until they left the nest. We all need to be reminded we're loved.

• Send a friend a great horoscope—it will make their day.

• Buy a handsome thermos so you can bring a hot drink to a friend you meet for a crack-of-dawn work session. *Café au lait,* or some special treat to make a predawn event bearable!

• Make an "I care" basket for a friend who is bedridden. Line the basket with a pastel linen napkin or guest towel; fill with talcum powder, body cream, soap, a lemon, lime, apple and orange. Include a few small inspirational books, *Vogue, House & Garden, The New Yorker,* a tin of hard candies, a handkerchief, a pretty note pad and marbleized pencils. Decorate the handle with a bow.

• As a special treat to pamper friends, opt for champagne bottles in split sizes. Have chilled and ready to go. It's very special having a champagne bottle all your own.

• Bring a little bit of your vacation to a friend: fill a tiny marbleized box with white sand from Bermuda or seashells from the west coast of Florida and tie it with a multicolored ribbon. Take it to friends when you go to their house for dinner.

• Surprise someone very special in your life with a long-stemmed blossom for his office desk.

• Share in the excitement of a child's first snowfall by waking your child up early in the morning and having breakfast by the window, as the magic crystals dance through the air.

• Put a little flowering plant or bouquet on your child's table once a week. An old baby picture or a forgotten toy brings back wonderful memories.

• When your spouse is home sick for the day, leave a companion behind—your favorite novel, a little toy, an interesting magazine.

• A lovely gift for men, and one that enriches their shaving experience, is a silver-tip badger shaving brush from Caswell-Massey.

• Keep a basket of pretty postcards on the desk in your guest room in case your guest wants to send a note to someone.

• Prepare a special toiletries case for the man in your life and store it in his suitcase. Place little notes, "I miss you," "I love you," inside his shirts, under his handkerchiefs. As he unpacks, he'll find them and smile, thinking of you.

Living a Beautiful Life

YOUR OWN GRACE NOTES

165

THE ART OF LIVING AT HOME

One of civilization's tasks is to find rituals which
give human existence significance. The rites of
daily life are ritualized by suitable *rooms . . .*

JOHN BARRINGTON BAYLEE,
president of Classical America

Rituals create moments where living becomes art. Poets, writers, painters and musicians aspire to heightened moments of awareness, times when they feel they have something unique and inspiring to give to the world. Most creative people do what they do because there is something burning inside them; they need to create in order to live. I believe we all have this instinct to create beauty, distinction, meaning in our lives. Your daily and lifetime rituals can define you, and they can keep your spirits up: they are important, for you, for your family and friends. They reflect—and shore up—your personality; they are your thumbprint, they become you. We don't think and care about beauty and finishing touches only when others are watching; we care about them for ourselves. We think about beauty and pay attention to details because it makes our days rich and full of beautiful moments.

Your rituals help bring the best of you into focus. You will be more intensely aware of your five senses. Rituals provide you with fertile soil by helping to develop your most significant sense—your sixth sense of intuition. Use it to create your rituals.

167

"Gazing on beautiful things," Michelangelo once wrote, "acts on my soul, which thirsts for heavenly light."

The Impressionist painters, who stressed nature in all their work, can guide us. Look for natural beauty in all things. Beauty encourages us; it gives us the joy and energy to care more and not to settle for less.

Pierre Bonnard assures us that "anything can turn to beauty." And one of the great inscriptions carved on the entrance to the New York Public Library on Fifth Avenue reads, "Beauty, old yet ever new; eternal voice and inward word."

Home can mean everything; it can open doors to a rich interior life.

The other day a dear friend handed me a Matisse postcard on

which she had copied the words of Ruth St. Denis, the great American dancer: "How in the end can one possibly hold anyone responsible for our own underdeveloped visions, or undeveloped strength of character?"

After all—to paraphrase another—all we really have is nature, our rituals, time and each other.

To improve the golden moment of opportunity
and catch the good that is within our reach
is the great art of life.

SAMUEL JOHNSON

INDEX

ABOUT THE AUTHOR

ALEXANDRA STODDARD, a leading expert on beauty and design, now heads her own design firm, Alexandra Stoddard Incorporated, having formerly worked with the New York City company of McMillen, Inc. Articles by her and about her have been featured in numerous magazines, including *House Beautiful, House & Garden, Glamour* and *Harper's Bazaar*. Her work appears in homes and businesses all over the United States, and she lectures widely, both here and abroad.